PEMBERTON
THROUGH TIME

MARIE F. REYNOLDS

AMERICA
THROUGH TIME®
ADDING COLOR TO AMERICAN HISTORY

Dedicated to my diligent research assistants
and dearest source of inspiration:

David, Blake, Ryleigh, Dillan,
Braydan and Graysan.

Look back. It's a means of moving forward
with knowledge and pride.

AMERICA THROUGH TIME is an imprint of Fonthill Media LLC

First published 2015

ISBN 978-1-63500-000-9

Typeset in Mrs Eaves XL Serif Narrow
Printed in the United States of America

Published by Arcadia Publishing by arrangement with Fonthill Media LLC

For all general information, please contact Arcadia Publishing:
Telephone 843-853-2070
Fax 843-853-0044
E-mail sales@arcadiapublishing.com
For customer service and orders:
Toll-Free 1-888-313-2665

Visit us on the internet at www.arcadiapublishing.com

Introduction

Pemberton Township and Pemberton Borough, Burlington County, New Jersey, USA, cover a combined sixty-five square miles of land in a region nearly equidistant from New York and Philadelphia that remains fringed by farmland and the New Jersey Pinelands.

The pioneer landowners and settlers of the Pembertons were "men of sterling integrity and good business habits," according to historical chronicles of 1883. They arrived from Europe and quickly set about establishing mercantile businesses and enlarging their families. When, in November 1681, the first form of government was established to tame the wild forests of New Jersey, some of the most prominent names in our twenty-first century community were seated at the table.

Initially, the natural features of the terrain were the greatest assets to settlers. The Rancocas Creek and its many tributaries offered prime locations for the grist and saw mills from which both Pembertons sprang.

Pemberton Borough, known as "Hampton Hanover" for sixty-two years and "New Mills" for the next seventy-four, was incorporated as the Borough of Pemberton on December 15, 1826. The saw mill, built in 1752 on what is now Hanover Street, was joined by a forge and furnace that operated until the mid-1800s. As operations at the mills and forge grew, so did the town's occupants.

By 1882, Pemberton Borough was flourishing. Saw and grist mill operations grew to replace the forge, the furnace was now the churchyard and the tannery property was sold off as building lots. There were three churches, six general stores, three blacksmith shops and one wheelwright. Two hotels, a public school building, two railroad depots, three physicians, a cabinet-maker and an undertaker ushered the Borough into the new century.

Meanwhile, Pemberton Township was not incorporated until twenty years after the Borough, on March 10, 1846. During that first meeting of the township fathers, $200 was raised to fund the school and $600 was voted as the levy for annual municipal expenses. With acreage many times that of the Borough, the township's livelihood was diverse.

Hanover Furnace in the northeast corner of the township turned bog ore into iron, and Mary Ann Forge near Mount Misery formed its own industrial hamlet. Dense pine and oak timber was leveled and hauled by mule and man to supply fuel for the Camden and Amboy

railroad engines. Cranberry growers tried, failed and tried again during the mid-1800s to perfect the crop that thrives here to this day. There was no shortage of trade.

Browns Mills, in the center of the township, took a different trajectory. It claimed fame as a healing resort. Seven miles of cedar-water lake and the dense pine canopy offered haven to those suffering from le' grippe.

Capitalizing on the healing power of sulphur and iron springs, small boarding homes sprang up throughout town. The advent of those homes led to the development of stately hotels and a legacy among wealthy travelers at the turn of the century.

A marketing campaign in 1916 by the *Philadelphia Press* offered a lot in Browns Mills for $39.20 with every six-month subscription to the paper. The acquisition and development of these tiny building lots contributed greatly to the town's reputation as a summer resort.

Five months after the declaration of World War I in 1917, some 22,000 draftees arrived at nearby Camp Dix for Basic Training. The conversion of land from farm fields to pup-tent cities to a full Army training base spanned the next ninety-two years, and played a huge role in the development of Pemberton Township and Pemberton Borough. Many of those who passed through for training came back after serving the country and settled here. Fort Dix, as it was later known, continues as Joint Base McGuire-Dix-Lakehurst (MDL), the nation's first three-branch military facility.

It is clear that the buildings shaping the outline of our boundaries do not solely define our history. In looking back at the Pembertons, one must not ignore the people who erected those buildings, or moved them from one end of town to another by oxen sled in the dead of winter. They were stalwart, industrious, and often fascinating. That was as true in the 1900s as it was a century before.

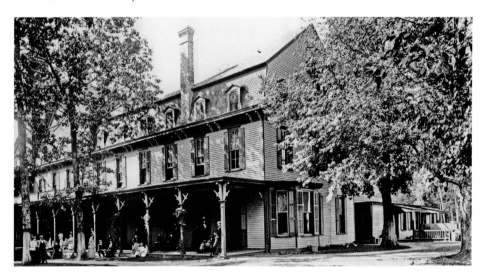

SCATTERGOOD BOARDING MANSION: One could board in the early pubic houses of Browns Mills for about five dollars a week, which often included a ticket by wagon from Philadelphia to Bordentown. From there, the trip continued by boat and then carriage, spanning eleven hours total. One of the first large boarding homes, Scattergood's, stood on Lakehurst Road near what has since become the main dam area, from 1854 to 1876.

Take, for example, "Aunt" Mary Asay, who died on June 2, 1937 at the age of 114. Born in Philadelphia, Mary Asay was reported to have worked as a buyer for Wanamaker and Brown in her "maiden" years, and later as a factory weaver. She made clothing for soldiers during the Civil War and helped with White House decorations for the inaugurations of Presidents Buchanan and Cleveland.

By 1900, she found herself in Pemberton, working as housekeeper to the Thomas Emmons family. In 1921, at the age of ninety-eight, she was admitted to the Burlington County Almshouse for the indigent. There, for the next sixteen years, she celebrated her birthday each year by singing in English, German and Spanish to the many friends who assembled. On her good days, she also danced a jig. At the time of her death, she was believed to be the oldest person in America.

William Seeds' fame was unfortunately posthumous. A story about the auction of his Pemberton land and family heirlooms in March 1928 was picked up by the Newspaper Enterprise Association (a frontrunner to the Associated Press) and ran in newspapers across the country under the headline: *"Queerest Auction Recorded".*

At eighty-five, William was the last survivor of his family and lived on a farm on Pemberton Road purchased by his father Jacob in 1860. A Civil War veteran, William confided to neighbors that his failing health was a worry.

He opted to auction the 100-acre farm and his numerous family possessions to assure him the financial security to board in comfort for the remainder of his life. Soon after planning the auction, however, Seeds became seriously ill. On the day of the sale, he lay on his deathbed in a second-floor bedroom as the auctioneer bellowed in the front yard below. Priceless antiques, Civil War relics and the family's acreage fell to the gavel for a

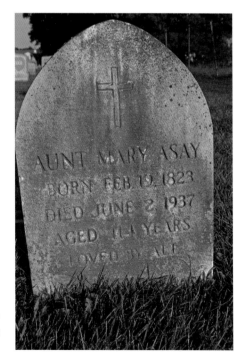

LOVED BY ALL: Although indigent at death, Mary Asay's many friends, including county officials, purchased a plot for her in Odd Fellows Cemetery in Pemberton Borough. The Grobler Funeral Home donated the funeral by agreement made several years earlier with the late Augustus Grobler.

pittance. When it was over, his single question "What did the farm go for?" was answered by a friend: "Forty-five hundred dollars." William Seeds died the following day.

Certainly, there were more famous inhabitants of the area; like Dr. Robert Keely, who traveled to the Artic with Admiral Peary in search of the North Pole, or Owen Wister, the father of western fiction. Col. Thomas Reynolds, who operated the mill in Pemberton, was said to have hidden from the British in a barn behind his Pemberton Borough home during the Revolution. He was captured by the Redcoats and held prisoner for several months before his exchange for a British officer won him freedom. New Jersey's sixteenth Governor, George F. Fort hailed from the borough also, in a home that still stands on Elizabeth Street.

Joseph Bonaparte, exiled king of Spain and brother to Napolean, brought royal and exotic guests to Browns Mills to share the great health resort, and President Woodrow Wilson once delivered a speech on the porch of the Birmingham Inn. When the handsome financier Edward Stokes shot James Fisk in a Manhattan hotel in 1872, it was widely reported that the motive for murder was a love triangle and the many trysts Fisk enjoyed in Browns Mills with Josie Mansfield, a well-known actress of the day.

Little known, famous, or infamous, Pemberton's people have shaped a unique course for us to follow. Across the decades, they have claimed the land at their feet as worthy of being worked. They've built foundations, laid block and shaped neighborhoods while revering the natural resources at the root of our being. In 2014, as in 1820, the Rancocas Creek rolls steadily over the dam, mindless of the traffic on the steel bridge above, and a solitary path through the fragrant pines offers sweet respite from the noise of the world.

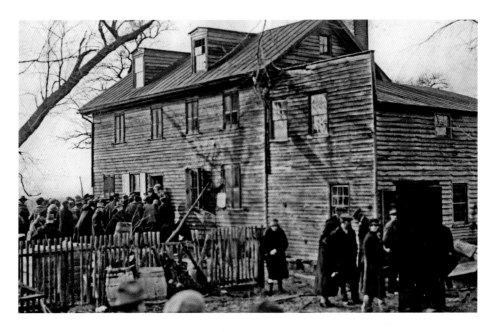

A STORY READ AROUND THE COUNTRY: This photo ran as far away as Provo, Utah along with the newspaper article detailing the unfortunate circumstances surrounding an auction held on Pemberton Road at the home of William Seeds.

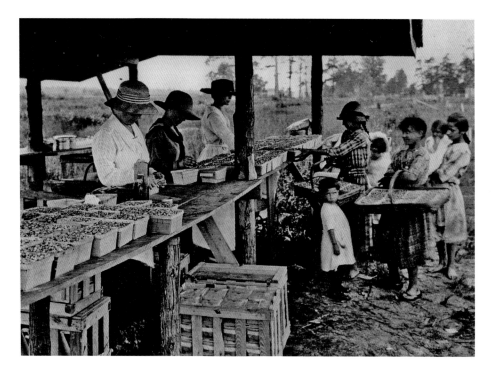

HOME OF THE CULTIVATED BLUEBERRY: Whitesbog Village in Pemberton Township was the site of an alliance between Elizabeth C. White and Dr. Frederick Coville in researching a better blueberry. Their hybrid experimentation with wild blueberries resulted in the cultivated blueberry we know in 2014. Above, Elizabeth White, first on left, checks the berries brought in from the fields. Below, the General Store is open on the weekends and tours of the preserved village are guided by volunteers.

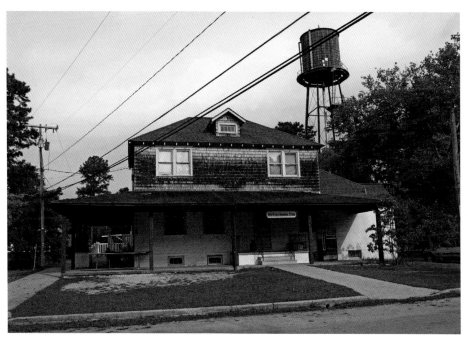

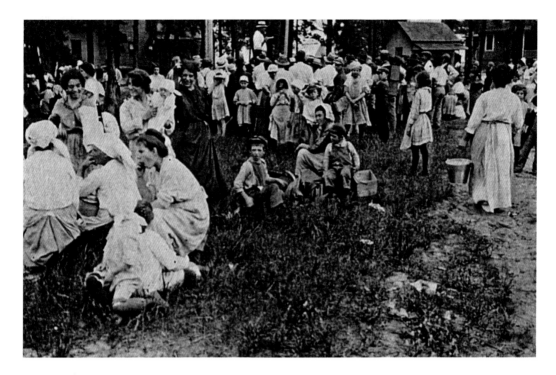

WAITING FOR THEIR PAY: During harvest, entire families of pickers came by train from South Philadelphia to Whitesbog. The Italian immigrants lived in two villages known as Florence and Rome. The village had a general store, a post office, a schoolhouse, and perhaps most important to families—a paymaster's station. Here, workers await their turn at the front of the station for their week's wages. The Paymaster Station still exists as part of the restoration undertaken by the New Jersey Department of Environmental Protection and the Whitesbog Preservation Trust.

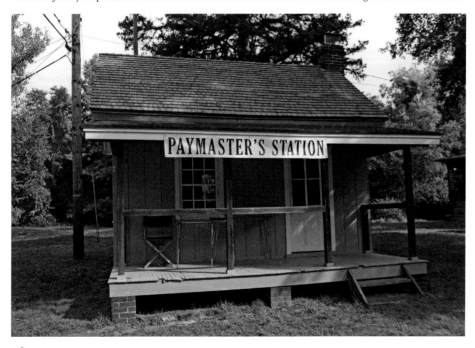

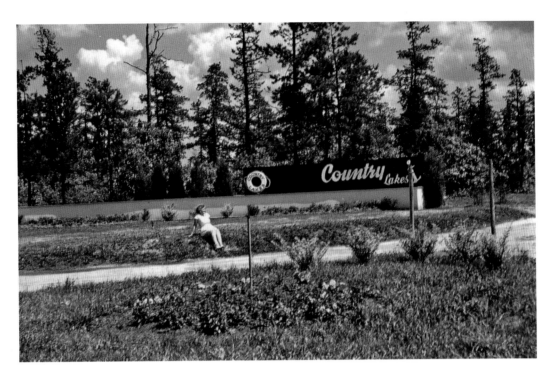

HOUSING BOOM IN THE POST-WAR YEARS: Ramona Earlin Montovani sits at the entrance to Country Lakes Estates, one of many single-family home developments taking shape in the township in the early 1950s. Building began there in 1953, the same year as Presidential Lakes, and involved over 5,000 lots. Pemberton Manor, Blueberry Manor and Sunbury Village added 575 homes to the local stock in those same years. In 2014, the entrance to the development is home to an apartment complex and the Country Lakes Shopping Center.

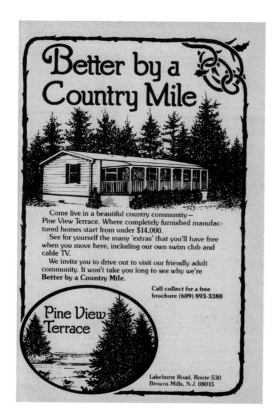

Come live in a beautiful country community—
Pine View Terrace. Where completely furnished manufac-
tured homes start from under $14,000.

See for yourself the many 'extras' that you'll have free
when you move here, including our own swim club and
cable TV.

We invite you to drive out to visit our friendly adult
community. It won't take you long to see why we're
Better by a Country Mile.

Call collect for a free
brochure (609) 893-3388

Pine View
Terrace

Lakehurst Road, Route 530
Browns Mills, N.J. 08015

BETTER BY A MILE: One of four mobile home parks in the township, Pine View Terrace is a senior community located on Lakehurst Road that has been in operation since 1964. While prices for manufactured homes have certainly risen since the park's original advertising, mobile home life continues to thrive. Pine View Terrace, Belaire Park, and Hilltop and Lakeshore Mobile Villages are home to approximately 600 Pemberton Township residents.

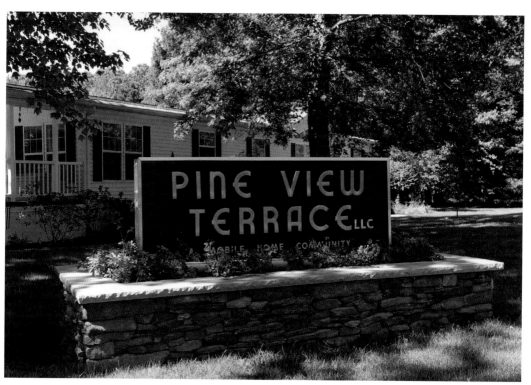

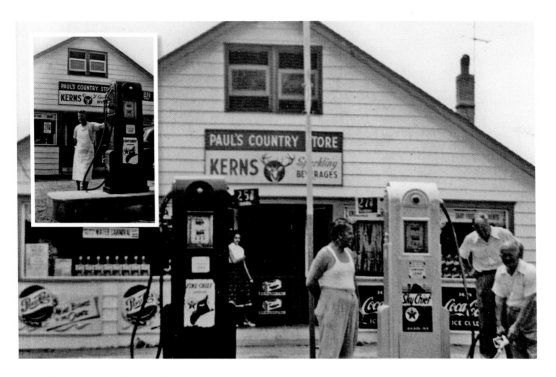

GAS AND SO MUCH MORE: If you look closely at the signs in front of Paul Kern's Country Store, on Lakehurst Road in Browns Mills, you can see that regular gasoline was selling at twenty-five cents per gallon, and premium gas at twenty-seven cents per gallon. The store also offered a variety of staples for local families. M&T Getty in that location in 2014 offers much the same when both the store and gas station are in full operation, but at much higher prices.

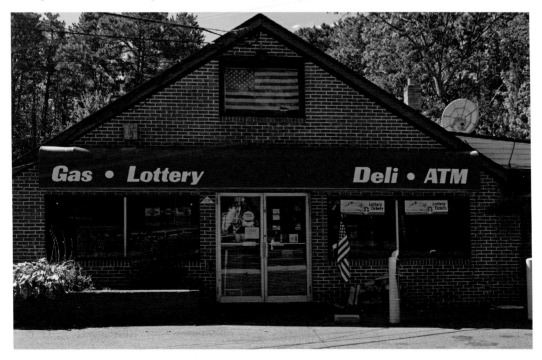

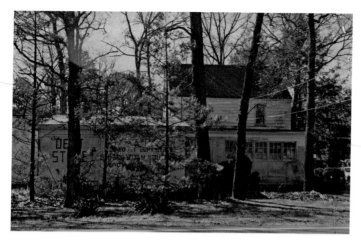

A Home for Entrepreneurs: One did not have to venture out of the area for fine women's and children's apparel in the Fifties. That could be found at Vivian's on Juliustown Road. The building still stands and last housed a shoe repair shop. Tenia's Department Store on Lakehurst Road has been demolished, but once stood as a popular shopping place for many local families due to the generosity and very flexible payment plan offered by owner Tenia Sternberg. Peebles Department Store in the Pine Grove Plaza at Trenton and Broadway was built in the second phase of the shopping center that added 70,000 square feet of space in 2000. It offers a full line of family clothing as well as household goods and accessories.

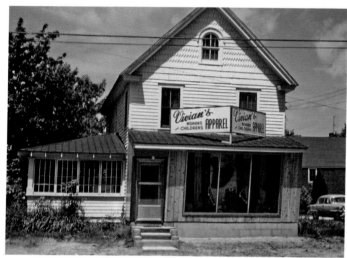

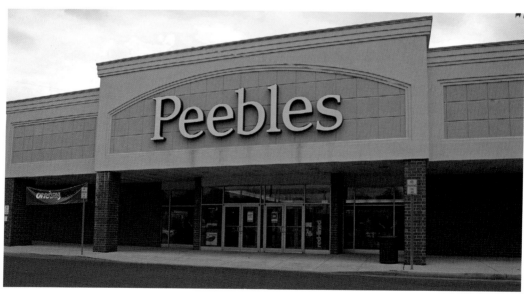

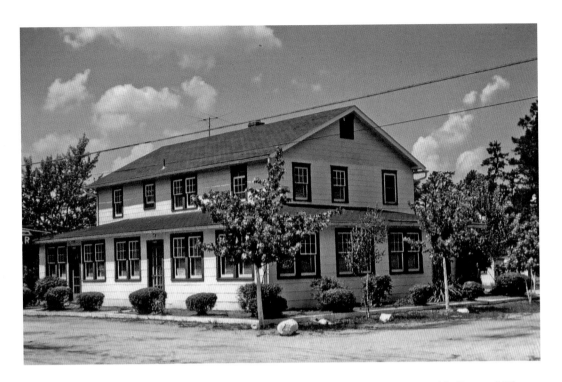

THE SPEAKEASY TAVERN: Originally Monihan's, the bar on Lakehurst Road in Browns Mills was later dubbed The Speakeasy and later still as Fat Rocks. Frequented by military and civilian employees from the nearby Army and Air Force installations, as well as locals, it was packed on weekends and full most weeknights in its heyday years. Extensive renovation and reconstruction of the building saw the opening of the Moore Funeral Home in 1999.

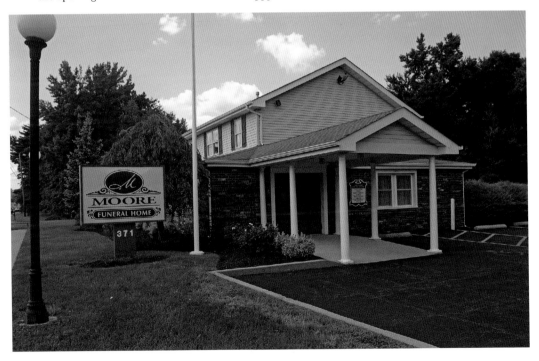

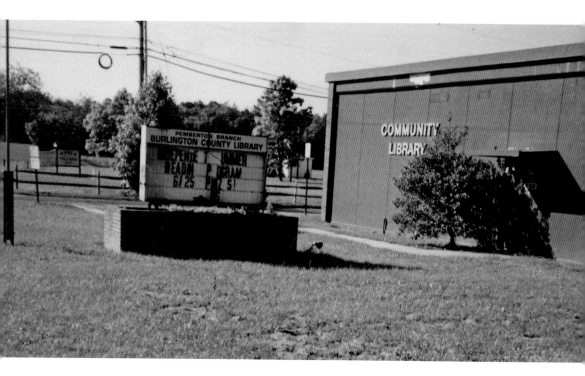

ALWAYS AT HOME IN THE LIBRARY: The original Pemberton Township Library occupied two storefronts in the old Acme Shopping Center on Pemberton-Browns Mills Road and moved to the Lakehurst Road location opened in 1984. Both the borough and township library branches joined the Burlington County Library System in 1987. The borough branch was closed when the new 18,000-square foot Pemberton Community Library branch opened on Broadway in Browns Mills in 2001.

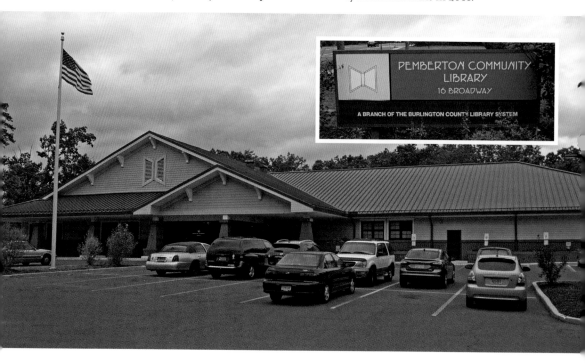

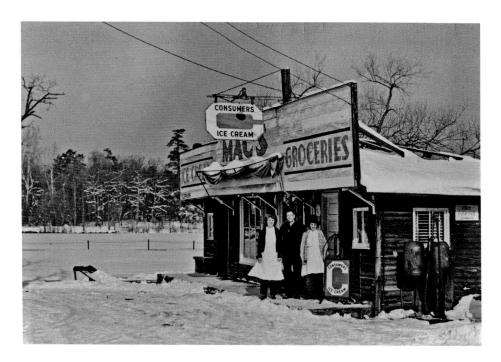

YEAR-ROUND SERVICE: One might think a grocery store catering to lake-goers would slow down during the winter, but not Mac's. While the inventory might have changed, Mac's remained open during the winter months and stood ready to serve local residents who put away their bathing suits and picked up their ice skates. Up until the late 1970s, a township truck was driven across the surface of Mirror Lake when the ice was suspected to be ready for skaters. If the truck made it across safely, a green flag was posted on a street pole and the lake quickly filled. Reflections Park continues that tradition of community with the annual Lions Club Tree Lighting Ceremony and other events in the early twenty-first century.

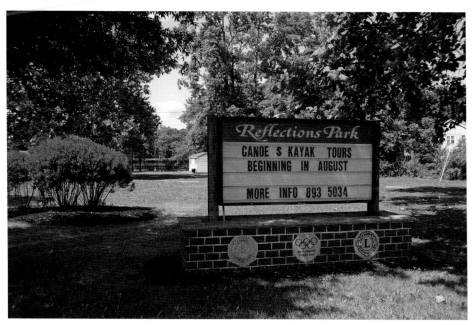

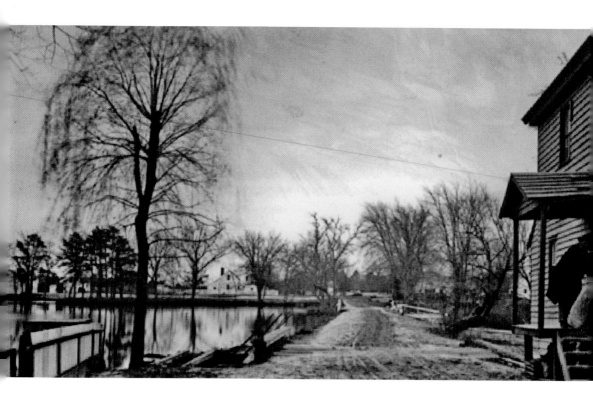

DAM SURVIVES MANY ITERATIONS: If Mirror Lake is the diamond of Pemberton Township, its setting has undergone many changes over the years. In 1864, above, there was little to stop a cart from running over the edge of the road and into the depths of the lake. Eventually, a railing and lights were added and the berm of the road was elevated to protect newer modes of transportation.

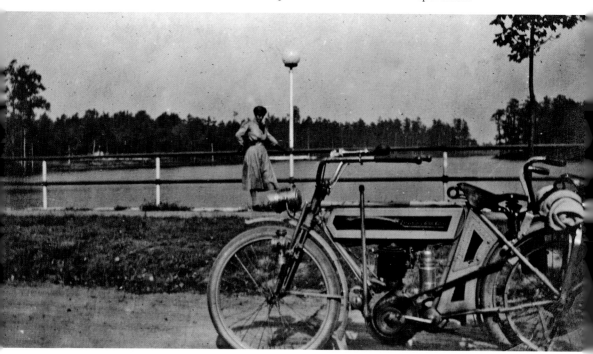

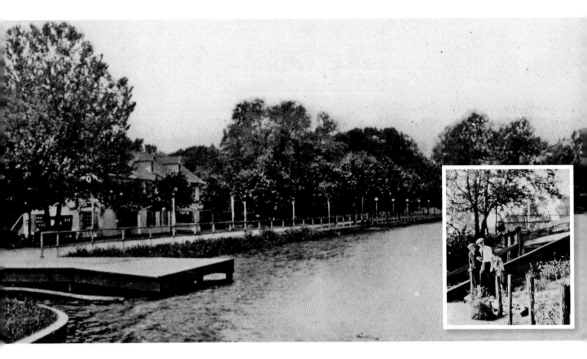

INTO THE BRINK: Even with the addition of guide rails and lights in the late 1920s, emergency personnel pulled at least a few vehicles out of the water each year. The first dam formed a chain of five lakes: Mirror, Big Pine, Little Pine, Squirrel and Wild Fowl Lakes. Little security was offered to pedestrians on the opposite side of the road where water released into the Rancocas Creek. If they were willing to climb down the wooden walls, the sandy lane overlooking the creek made a perfect place for a courting stroll by couples. Below, across from Pear Avenue, off South Lakeshore Drive, workers can be seen building the dock, with the channel in the foreground.

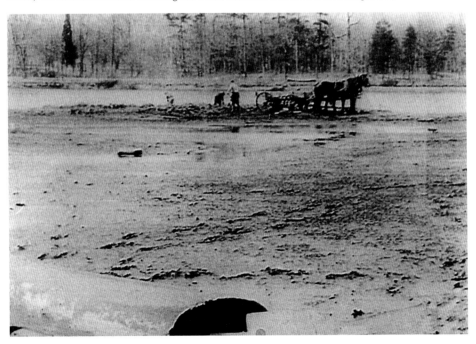

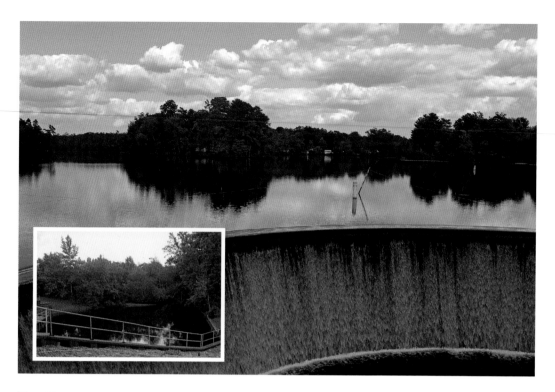

THE NEW MIRROR LAKE DAM: A more sophisticated dam design completed in 1993 provides improved spillway management on the lake side of the bridge and better drainage and security on the creek side.

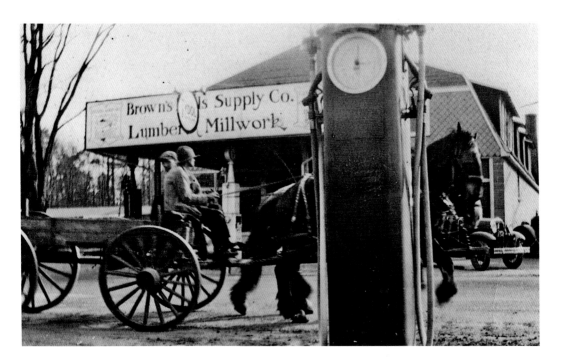

BROWNS MILLS SUPPLY COMPANY: After eighty years in business on Lakehurst Road in Browns Mills, Browns Mills Supply closed in October 2001. Family owned and operated by four generations of Hobarts, the supply company was started by Henry Hobart. He worked as a carpenter in Philadelphia and would bring customers to Browns Mills on the weekends to purchase lumber and materials. The original lumberyard and store were located across the street from the 2014 location. The building last used for the business was sold to Williams Paving, and has since become vacant.

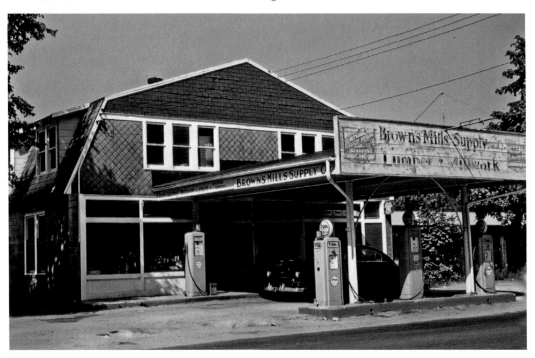

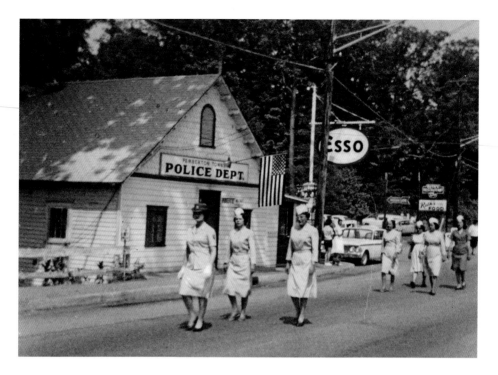

BOOMING BUSINESS LOCATION: Prior to the reconfiguration of land necessary to support a more efficient dam, building along the creek side of the road at Mirror Lake offered a prime location as well as a beautiful view. The building that housed the police department later served as home to the township water department. The Log Cabin Restaurant and Inn was a popular place for a home-cooked meal and an overnight stay. Behind it, the dance hall offered recreation for annual lake visitors.

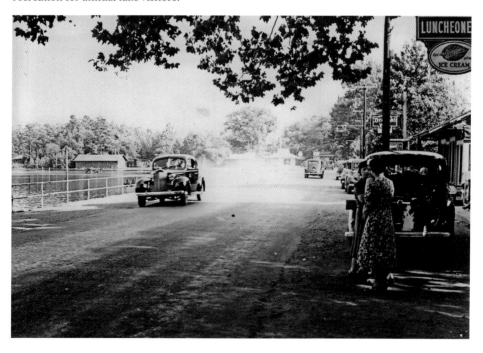

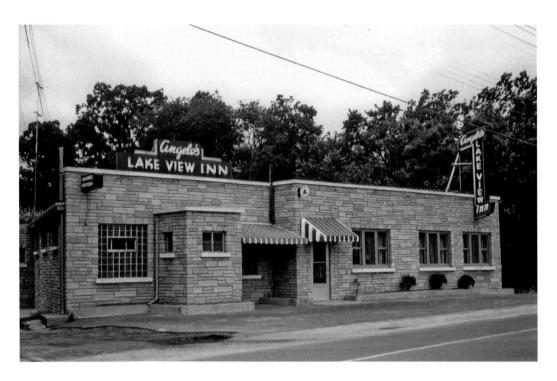

DINE AND BOWL: Angelo's Lakeview Inn was the last restaurant and bar to reside on the Mirror Lake Dam. Young men growing up in the area at its height tell of being paid a nickel a game to set-up pins in the four bowling lanes downstairs. Prior to Angelo's, the building housed a small café and ice cream stand. The Virtua Family Medicine Center serves the health needs of area families in that location in 2014.

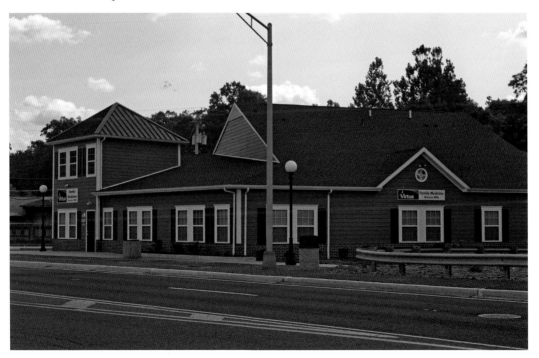

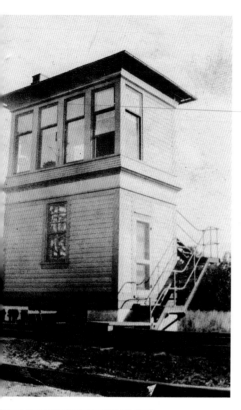

THE JUNCTION ROAD RAILROAD TOWER: This was a concession made by the town fathers who feared that bringing the railroad through Browns Mills would destroy the town. Travelers therefore purchased a thirty-cent jitney ticket to ride from the main dam to the tower less than two miles away. Once the Browns Mills Railroad Station opened closer to town, it operated from 1890 to 1938 near the intersection of Junction and Lakehurst Roads. In 1915, the Pemberton and Hightstown Railroad, along with the Philadelphia and Long Branch Railroad Company and the Kinkora and New Lisbon Railroad, were merged to form the Pennsylvania and Atlantic Railroad Company.

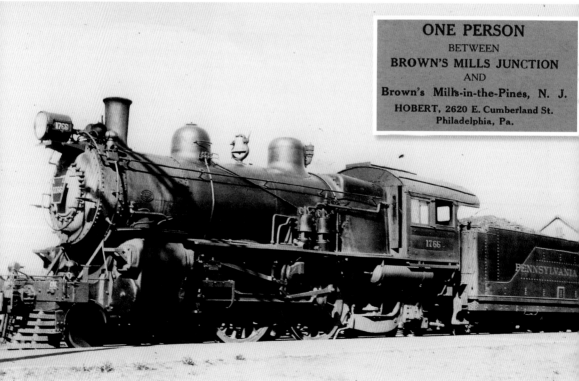

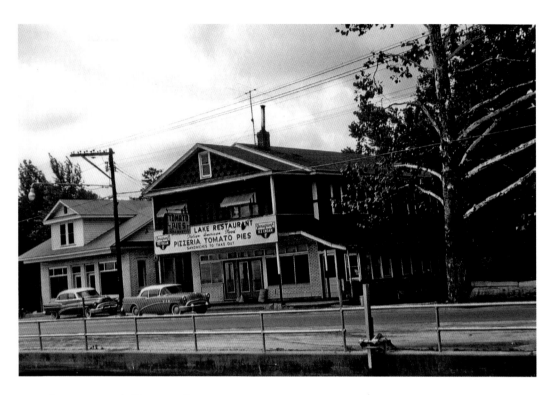

SORRENTINO'S TOMATO PIES: That was the specialty of the Mirror Lake Restaurant, and its ovens summoned swimmers from the lake with their aroma on a daily basis. The local eatery was destroyed in a deadly fire that claimed the life of one of its owners in 1973.

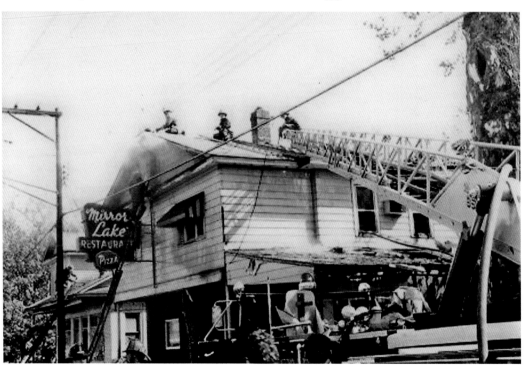

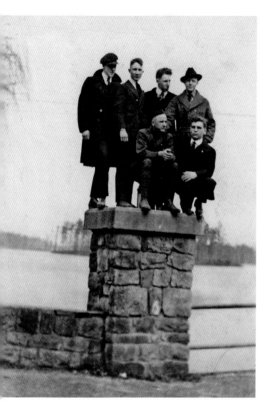

THE HAPPY SIX: That's how Ralph Hulick (third from left, top row) captioned this photo of himself and five friends perched on a pillar at the entrance to North Lakeshore Drive. It was from that location that one could rent a canoe or rowboat, savor a treat at the ice cream stand, or enter the bathing beach at Mirror Lake. Ralph Hulick was Postmaster of Browns Mills for many years as well as a business owner.

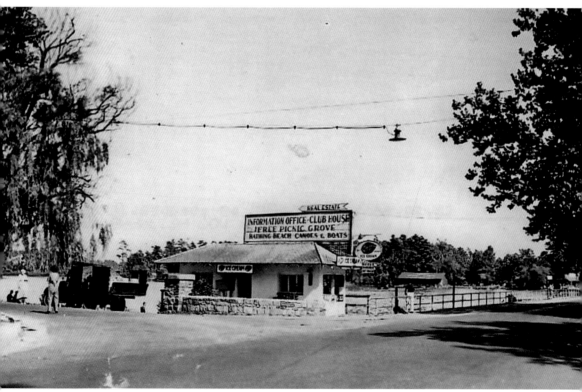

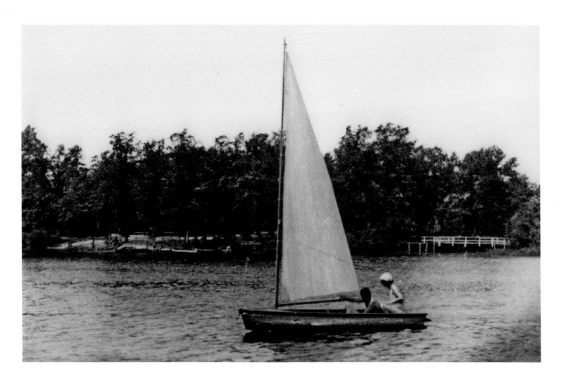

SERENITY ON A CALM DAY: With Love Ladies Island in the background, sailing on Mirror Lake was a beloved pastime for several generations. The view remains essentially unchanged. The tradition of the annual Water Carnival began in 1953 and continues through the Township Recreation Department each summer. Local businesses design and enter elaborate floats in a hotly-contested race for prizes.

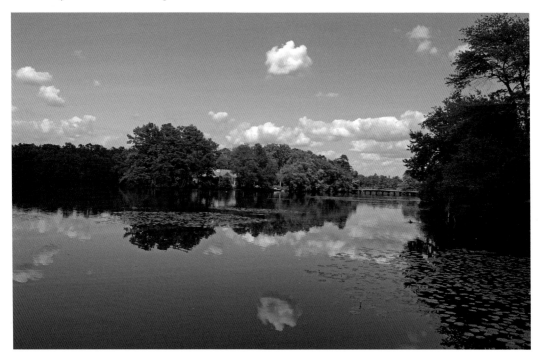

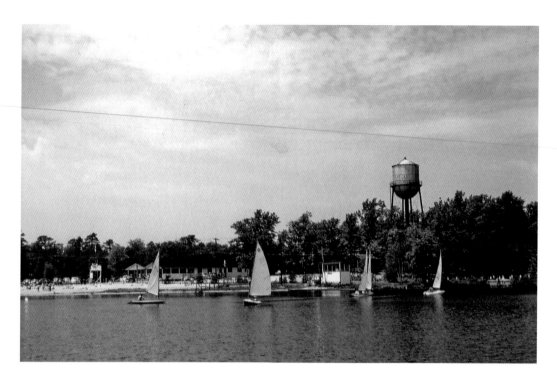

THE BATHING BEACH AT MIRROR LAKE: Each summer, residents take to the main bathing beach off South Lakeshore Drive for recreational opportunities. Swimming, paddle boats, canoes and kayaks are some of the water-related activities offered. The sailboat regattas of the past are no longer held, having given way to pontoon boats and small motor fishing vessels. Fishing along the entire length of the lake, as well as by boat, continues to be a fair-weather pastime.

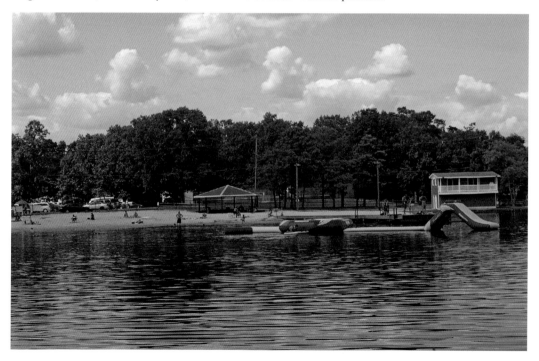

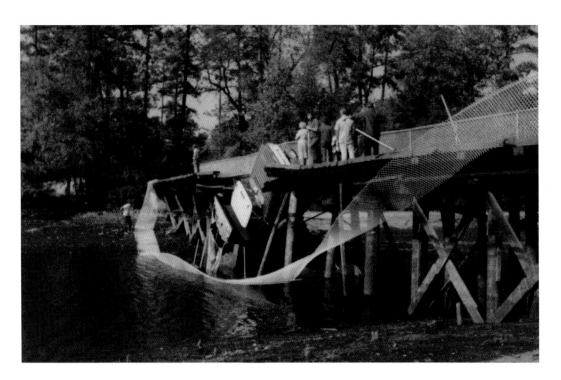

BRIDGE TO LOVELADIES ISLAND: Delivery drivers have begun to think twice about the trip to the Georgia home on the island in the middle of Mirror Lake. While it has been approximately forty years since the first truck plunged through the wooden bridge, a recent reoccurrence of the event left a septic truck stuck on the structure for nearly twenty-four hours while attempts were made to free it from the broken slats by cable.

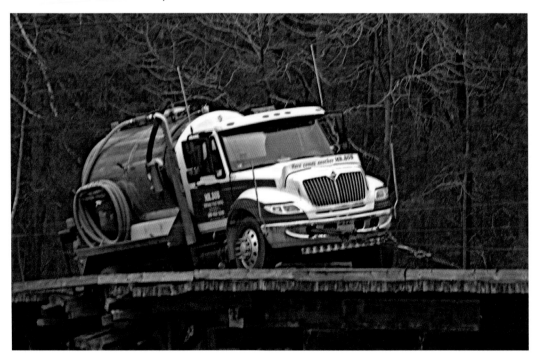

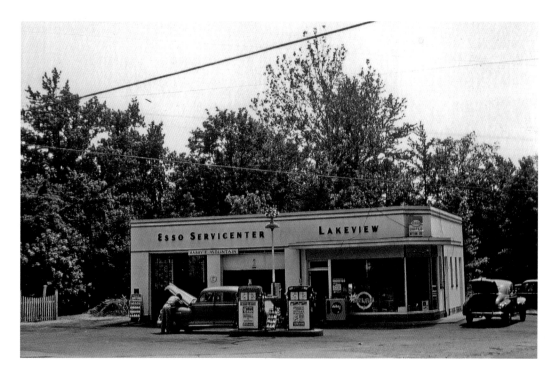

THE CORNER OF NOTEBOOM AVENUE: Here, one would find the Esso Service Center, which proudly proclaimed in its ads that employees would "cheerfully check your water, oil, tires, battery and wash your windshield" with every gas purchase. In 1960, the same building was converted and operates as a Domino's Pizza Restaurant and delivery service in 2014. Dominos Employee Heather Meyers takes a break from the ovens while there's a lull in orders.

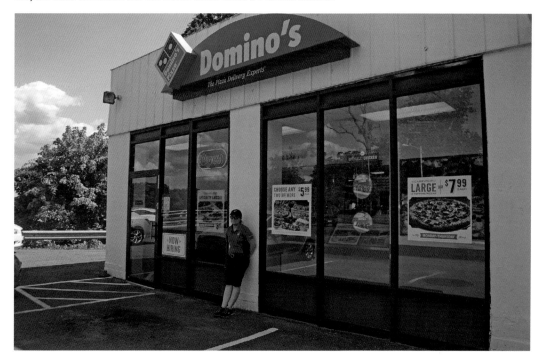

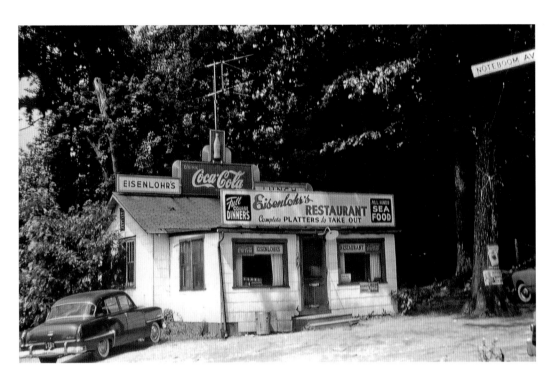

JUST BLINK YOUR LIGHTS: If you wanted curbside service at Eisenlohr's Restaurant, all one had to do was blink their car lights. Of course, you could also go inside for a variety of homemade dinner selections. While blinking your car lights will not get you service at Belly Buster's Bar and Restaurant in 2014, the location still touts a variety of homemade dishes to eat-in or take-out. JC Liquors and Lounge previously shared this same location.

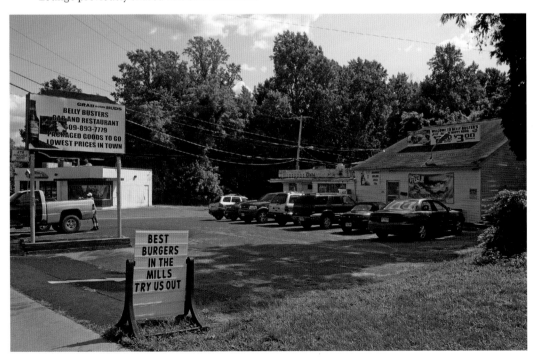

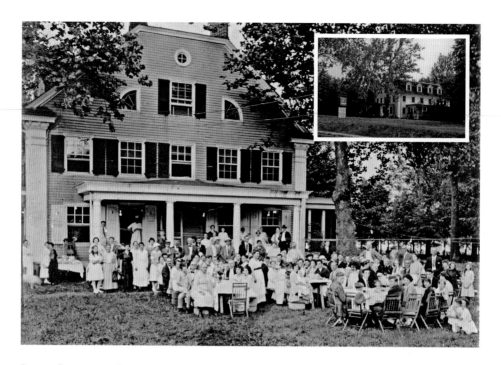

LONG-STANDING SYCAMORE HALL: Originally called Buttonwood, this building has served a variety of purposes in the township since it was built in 1776. The Colonial home was restored in 1910 as a boarding home with a hall accommodating 250 guests, and was a popular place for reunions and meetings. Kay Stull and her husband Walter later operated the Sycamore Hall Sanatorium in this location, and in 1942, Kay reopened as Kay's Gift Shop, hosting elaborate Christmas parties for the community each year. In 1973, Kay Stull sold Sycamore Hall to Fidelity Bank. The building stands vacant in 2014, but hopeful for future service to the community.

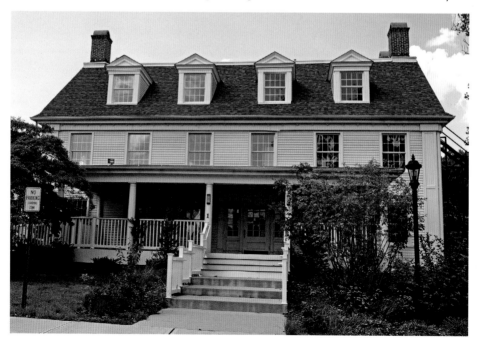

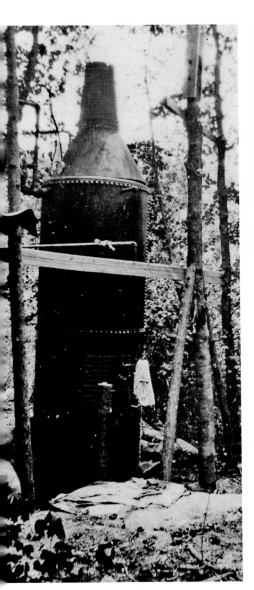
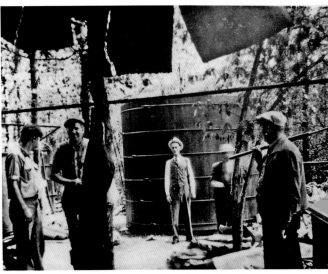
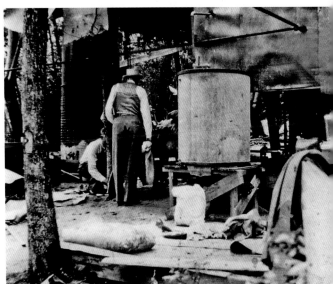

PEMBERTON DURING PROHIBITION: Kay Stull, whose husband Walter served as Township Clerk for many years, once commented during an interview that Prohibition had little impact upon the area. "Don't ask me where it was," she said, "but they had the biggest still up in Wood Nancy where they made applejack homebrew. You could buy liquor in darn near every place in town during Prohibition." These photos would seem to bear witness to those statements.

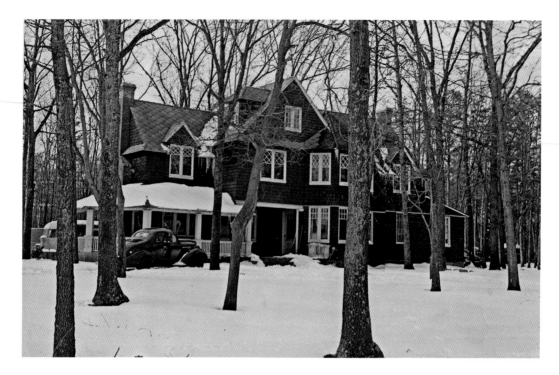

BUILT AS A HUNTING LODGE: The Lakeshore Lodge on North Lakeshore Drive was built in 1910 and was the home of Dr. Robert Keely. He traveled to the Artic as ship physician on the *Kite* during Admiral Robert Peary's first expedition to discover the North Pole. Keely also discovered cures for alcohol and tobacco addiction and wrote *Paris and All The World Besides* in 1930.

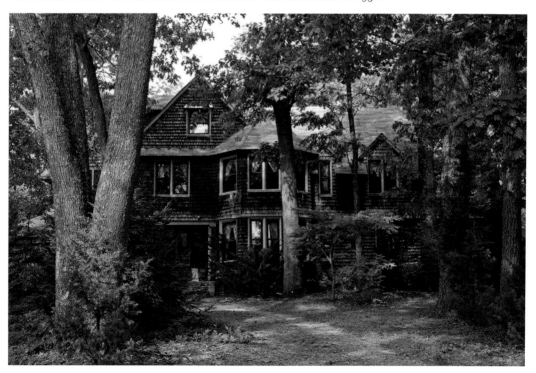

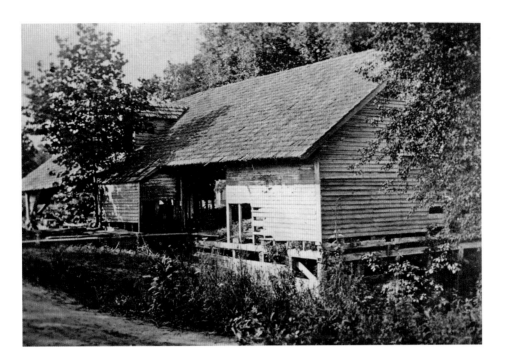

THE OLD PINE MILL: This mill was near Hanover Furnace on the south side of Hanover Dam in about 1879. Operations at Hanover Furnace began nearly a century earlier—in 1791. With a running stream, a constant supply of timber and a steady flow of bog iron, the furnace produced pig iron, stoves and water pipes. Over the years, the discovery of cannon balls around the 1000-acrte tract supported the theory that large cannons used to fight Algerian Pirates were also cast at Hanover and test-fired in the area. The land exists on Joint Base McGuire-Dix-Lakehurst in the early twenty-first century.

WARNING

The Hanover Furnace archaeological site is currently listed on the National Register of Historic Places. Unauthorized excavation on federal land is a crime; it is prohibited to excavate or remove archaeological resources without a permit (Federal Regulations: Archaeological Resources Protection Act of 1979; Army Regulation 200-4)

VIOLATORS WILL BE PROSECUTED

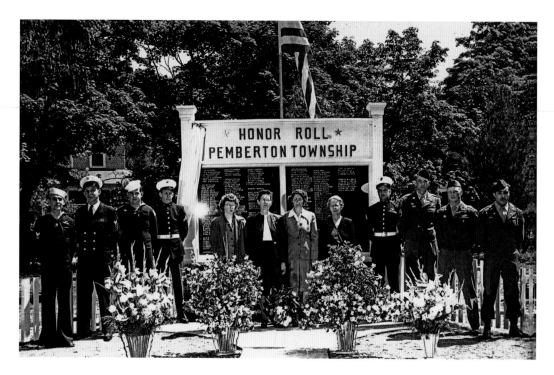

HONORING OUR VETERANS: Longtime resident John Hulick sets the date on the unveiling of the Pemberton Township Honor Roll above at approximately 1952. The township's new Veteran's Memorial Park was dedicated in 2011 and is located near the intersection of Lakehurst and Trenton Roads. Both Pemberton Township and Borough continue to hold annual observances in honor of veterans, from wreath-laying ceremonies in Mirror Lake to programs at local schools. The military influence in the Pembertons remains strong.

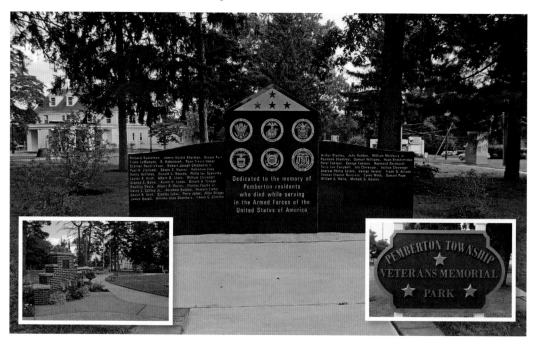

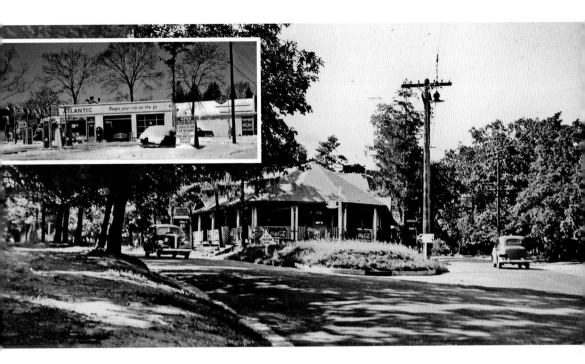

THE BELOVED AUDITORIUM: Standing at the crossroads of Lakehurst, Trenton and Juliustown Roads, the Auditorium was a mecca for lake dwellers. It housed—at various times—a lunchroom, a beauty and barbershop, the post office, a gift shop and a tearoom. Movies were shown in the back portion of the building and music was constant in the dance hall. The building was moved in June 1955 and the site has been home to two gas stations since that time, Hodgson's Atlantic and in 2014, the Shell Station. Hodgson's operated two Atlantic Stations simultaneously, including this one on the point and another on Hanover Street in the borough.

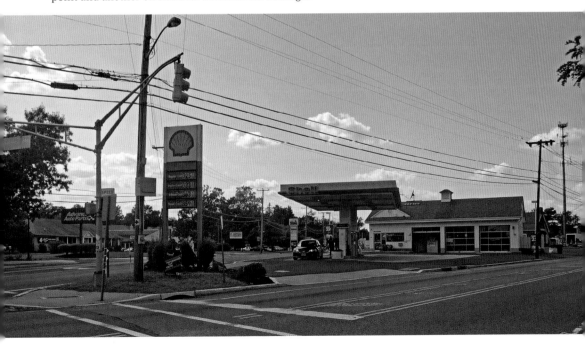

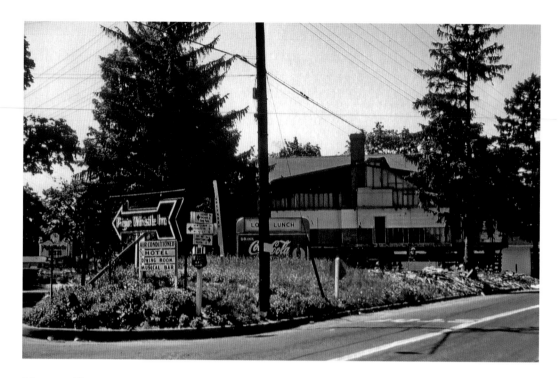

MOVING HISTORY DOWN THE ROAD: When the auditorium was moved in June 1955, many local residents came out to watch. The structure was towed from its home on "the Point" to a location between Noteboom Avenue and the Rancocas Creek. Here, Alex and Rose Dugalas planned to convert the building to an apartment house, but that plan never came to fruition and it was later demolished.

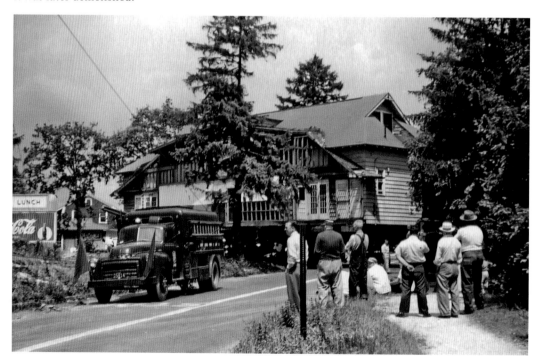

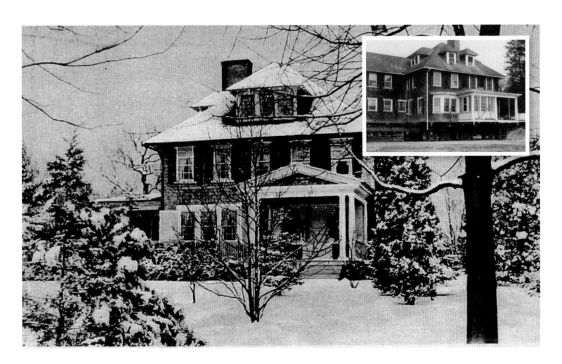

QUITE A LEGACY: The Hathaway Residence was located on Juliustown Road where Advance Auto Parts is in 2014. It was the home of Margaret Hathaway, the owner of a tearoom on the Mirror Lake Dam. For many years, the home was occupied by J. Lincoln Godfrey, vice president of the Pennsylvania Railroad. Upon Hathaway's death, Postmaster Ralph Hulick's family took up residence, and later sold it to Marc Williams. Williams donated the house to the township in the mid-70s. It was moved to Brook Street, where it exists as the Pemberton Township Senior Citizen Center.

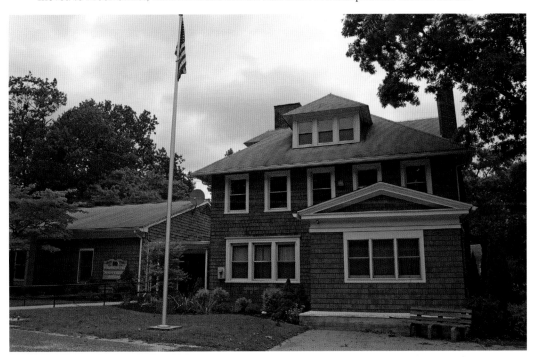

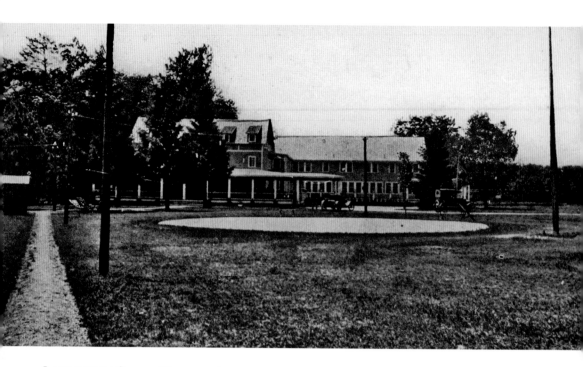

LAST OF THE GRAND HOTELS: The Pig n' Whistle Inn advertised its opening as 1832, but has long been thought to have been assembled from a number of buildings in its Juliustown Road location in 1905. It was a favorite spot for large reunions such as this gathering of YWCA chapters from across Pennsylvania. University of Pennsylvania alumnae also held documented two-day reunion events at the hotel with raucous games of sport. The photo below shows the wooden water tower that serviced the hotel. For many years, water was supplied from an artesian well near the Mirror Lake Dam.

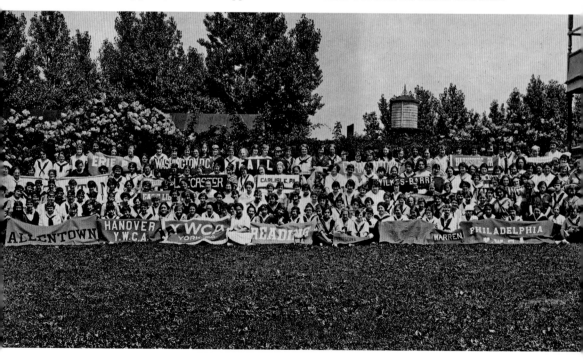

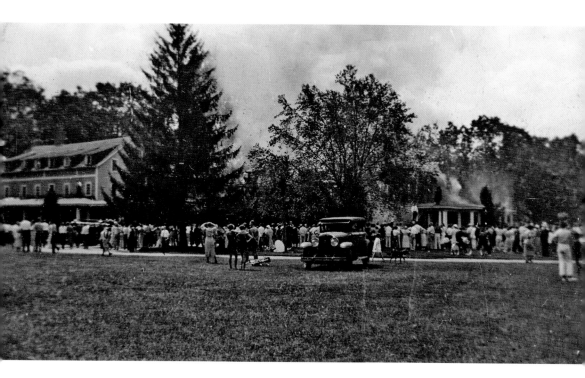

LOST TO SUSPICIOUS FIRE: The Pig n' Whistle Inn survived fires in 1927 and 1936 but succumbed to a final one that was deemed suspicious in nature in April 1972, marking the end of the grand hotels in Browns Mills. The Mill Village Shopping Center was built soon thereafter and has remained in business for more than thirty years, housing, among other ventures, the Pig n" Whistle Liquor Store.

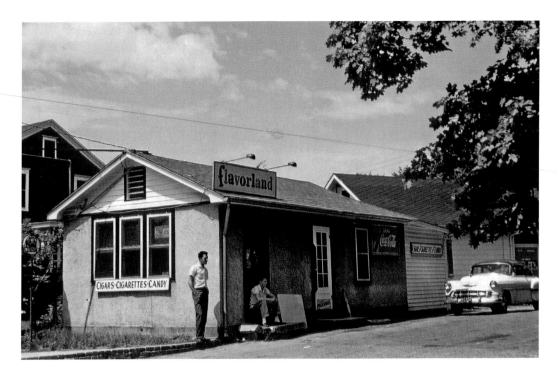

IN BETWEEN THE SHELL STATION AND CROWN REALTY: This is where a significant building to the community stood. Flavorland was a quick stop for a handful of candy or an ice cream cone while riding your bike through town. Earlier, it was home to Fred Wenzel's Bus Station and greeted visitors after a long bus ride from the city. Dick Taylor opened Crown Realty in 1974. Real estate sales at the time were driven by military families settling in after serving in Vietnam.

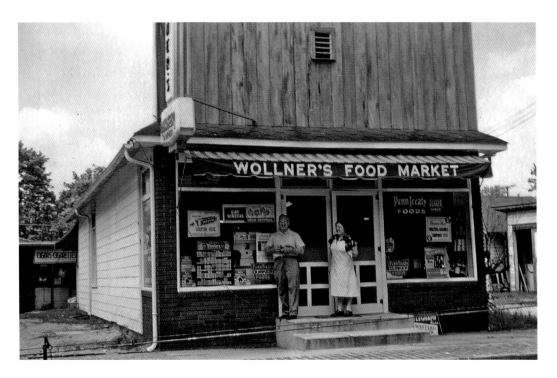

WOLLNER'S AND WENZELS: Hubey Wollner and his wife lived in a home right behind the store they operated on Trenton Road behind what has become the Shell Station. Their home backed up to Fred Wenzel's Bus Station (later Flavorland) and was one of the full-service grocery stores in town where shoppers would find staples for the week as well as fresh meats and produce. It operated from 1929 into the 1960s.

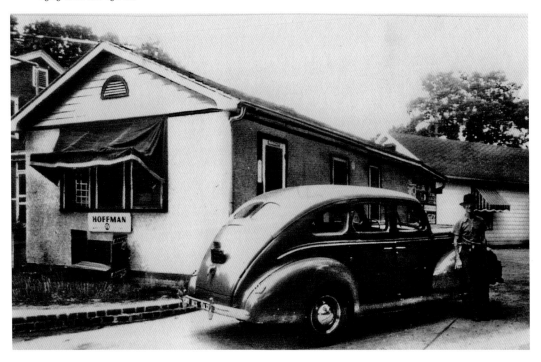

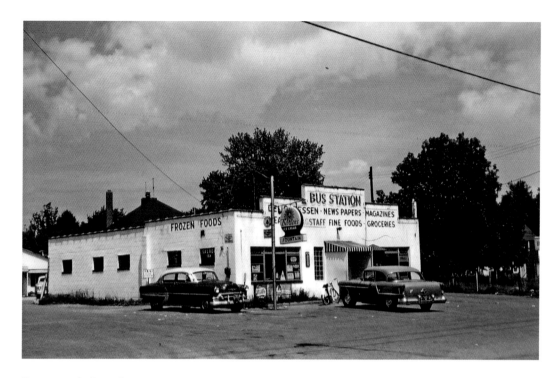

ERICKSON'S BUS STATION: When you got into town on the bus on Friday night, you could pick up your groceries for the weekend or sip a cool drink at the fountain at Erickson's. From about 1946 to 1948, taxi drivers in town jockeyed for the best place to park along Juliustown Road to pick up travelers and get them to their summer homes quickly. In 2014, weekend guests can pick up their laundry and grab a hot sub or a full Chinese dinner in the same location.

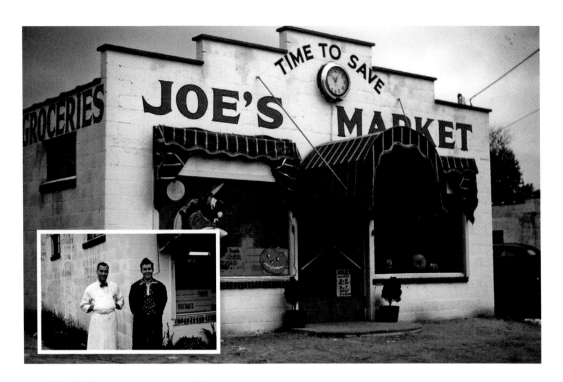

JOE'S SUPERETTE IN THE PINES: In July 1948 Joe McKinstry completed work on a larger market just down the street from the original on Juliustown Road. Joe and his wife Claire created elaborate window displays every holiday, and won first place for their Water Carnival window in 1953. Joe and son Charles are shown taking a break from the store's work for a moment. The Browns Mills Emergency Squad purchased the building in 1958 and later expanded it to twice its size.

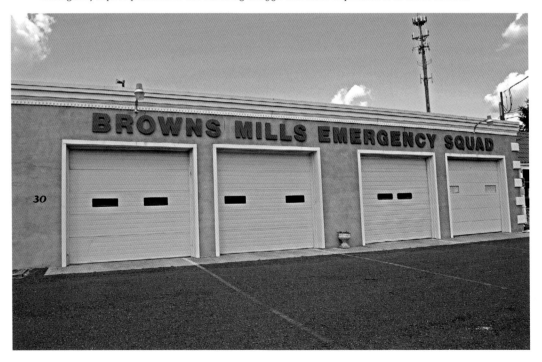

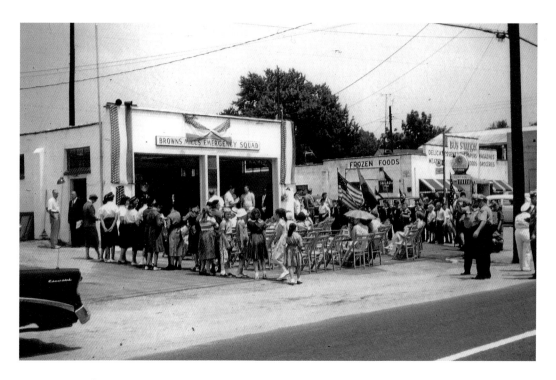

VOLUNTEER SERVICE: Above, the dedication of the new squad building in 1959. For decades, the fire and emergency medical needs of Pemberton Township residents were overseen by trained volunteers in several independent companies: The Country Lakes, Presidential Lakes, Magnolia Road and Browns Mills Fire Companies and the Browns Mills and Pemberton First Aid Squads. In 2013, the governing body created the Volunteer Fire and Emergency Services Company by local ordinance.

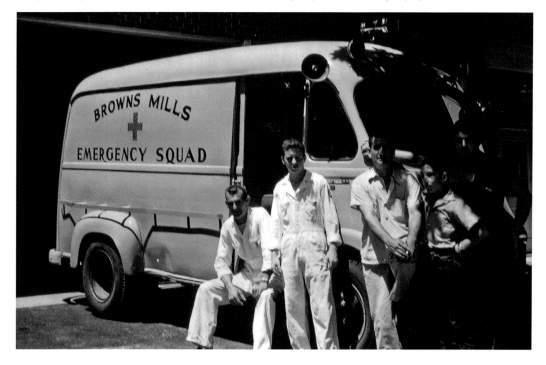

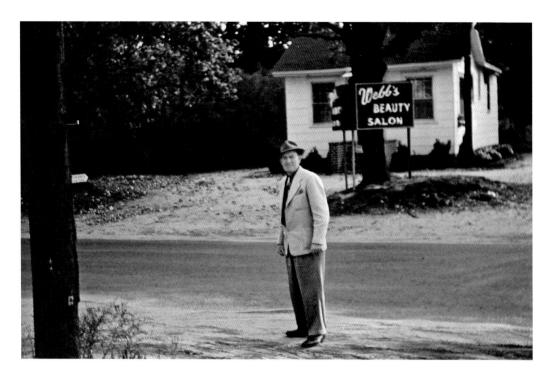

WEBB'S BEAUTY SALON: Dr. Charles Shore stops for a smile on his way to the bus station for the morning paper. A veterinarian from Philadelphia, Dr. Shore opened an antique shop where the vacant doctor's office is located on Juliustown Road, but subsequently sold it to a real estate company. Across the street from his store was Webb's beauty Salon, which later became Kim's. The quaint storefront still exists next to Rita's Water Ice in 2014.

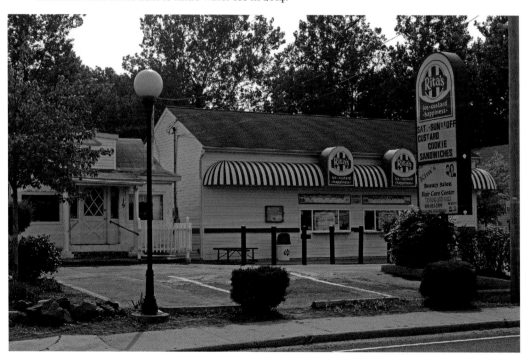

LEVY'S MARKET AND THE BROWNS MILLS POST OFFICE: In the late 1930s to early 1940s, the Browns Mills Post Office was housed on the left side of the building above and Levy's Grocery Store operated on the right. The structure has survived and served many purposes since that time, most notably as home to Little Pine Cleaners and Charles Van Horn Realty for many years.

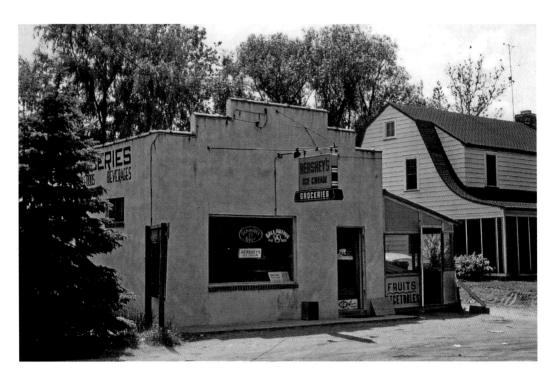

THE FIRST JOE'S MARKET: Joe McKinstry started out in the grocery business on Juliustown Road with partner Paul Douglas. From about 1940 to 1947, they ran the store next to the home of Catherine Haines, postmistress at the post office just next door. Her home still exists as a private residence, while the "Old Joe's" was replaced by the Apell and Detrick Law Firm in the 1960s. Erwin Apell and Paul Detrick practice probate, real estate, divorce and trial law in this location.

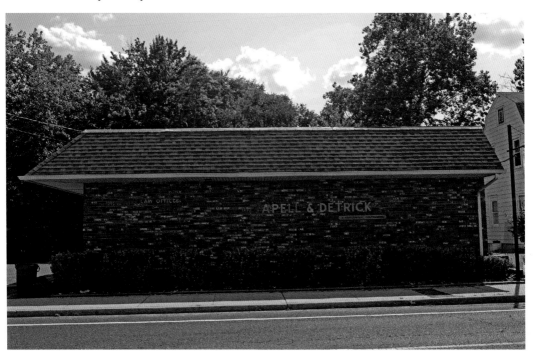

COME ON IN FOR A HAIRCUT: For many years, that was the greeting at the corner of Juliustown and Pemberton-Browns Mills Roads. George the Barber was in residence in a shop that has since been demolished, but existed right next door to Lou's Restaurant. Since the 1960s, however, that job has gone to Ernie at Ernie's Barber Shop across the street in the shopping center. He is now working on the fourth generation of local families in 2014.

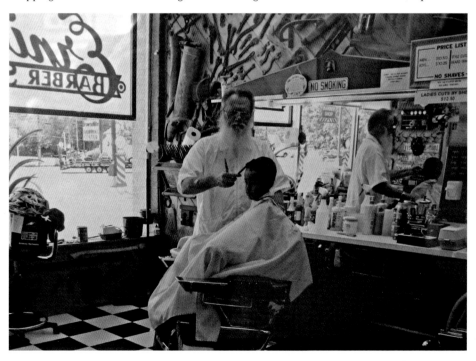

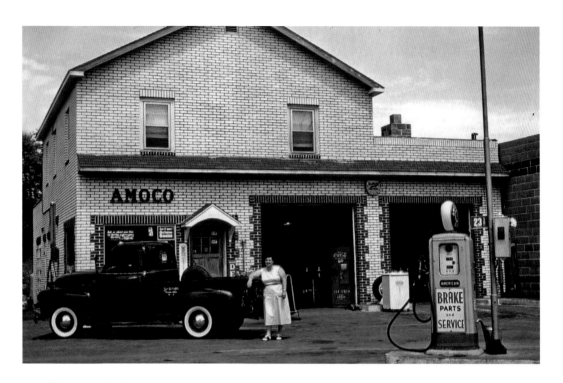

BROMLEY'S AMOCO: At the corner of Juliustown and Pemberton-Browns Mills Roads, Bromley's Amoco was a prime location to swing into for a dollars' worth of gas in early Browns Mills. Next-door, the Anderson Furniture Store helped many young families set up households on a weekly payment plan. Facing competition from Two Guys Department Store in Bordentown, James Anderson started his ads with the words "One Guy from Browns Mills". The station and store are long gone and replaced by the CVS pharmacy.

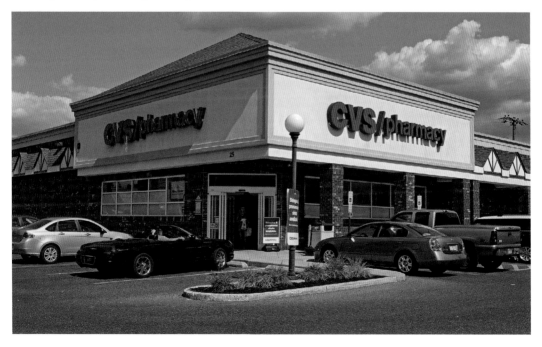

THE DEMISE OF WOLFIE'S DINER: When the first fast food restaurant was considered by the planning board in Pemberton Township, the owner of Wolfie's Diner, above, was a huge opponent. He argued that fast food would lead to the demise of all of the local eateries. Known for his tendency to collect plates and show customers the door when they complained about his food, Wolfie fought hard for the independent owner. Wolfie's Diner had been closed for several years before Burger King opened on the same corner lot.

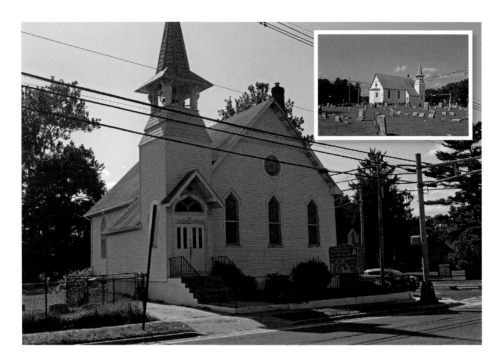

FROM POOLROOM BEGINNINGS: The Browns Mills United Methodist Church was originally purchased in 1873. The congregation paid sixty dollars for the poolroom structure and had it moved to the corner of Trenton and Pemberton-Browns Mills Road for a forty-dollar fee. On Christmas Eve 1898, members gathered for holiday services and many heard a graphophone for the very first time. The church burned to the ground by Christmas morning. It was rebuilt in 1899 and was later sold to St. Mark Baptist Church congregation when the new Methodist church (below) was erected a half-block away on Pemberton-Browns Mills Road. The original building serves as the First Pentecostal Apostolic Church in 2014.

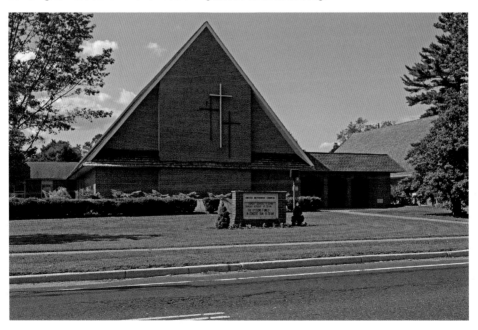

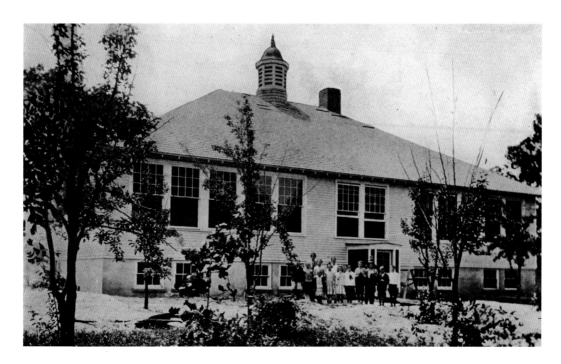

OUR LITTLE RED: Ask anyone who has lived in Pemberton for a lifetime and they will be happy to reminisce about their days at "Little Red." Officially known as Browns Mills School #1, the building opened in October 1919 at the corner of Trenton Road and Broadway, where it stands in 2014. It has served as an elementary school, a kindergarten building and finally as administrative offices for the Pemberton Township School District. Its upkeep and maintenance over the years by both the schools and the township has been admirable and was recently enhanced by the addition of a "town clock" and courtyard area.

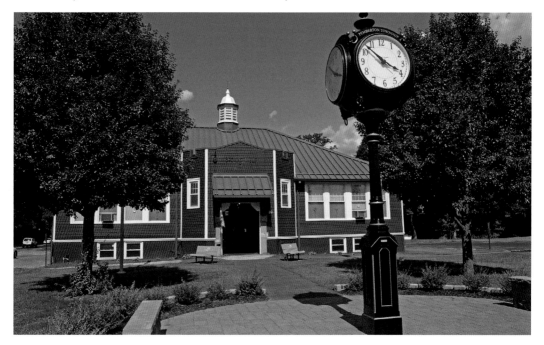

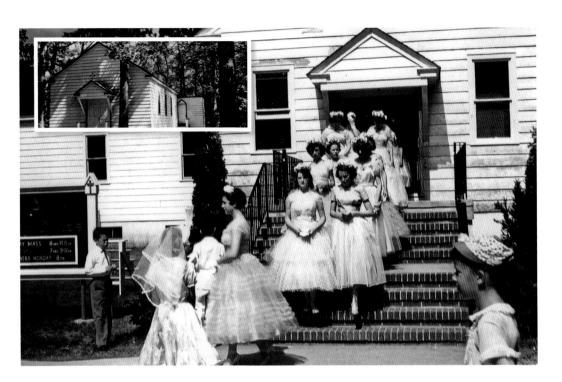

ST. ANN'S IN THE PINES: The first home of St. Ann's was moved to Trenton Road from its location on Noteboom Avenue in 1950. It was later expanded on the site to add a basement, annex and sacristy. In 1986, a new church was built with seating for 400, and the existing building was converted for use as a parish hall. An extensive Parish Center was added to the new church in 2002. The Center houses a preschool and the parish hall.

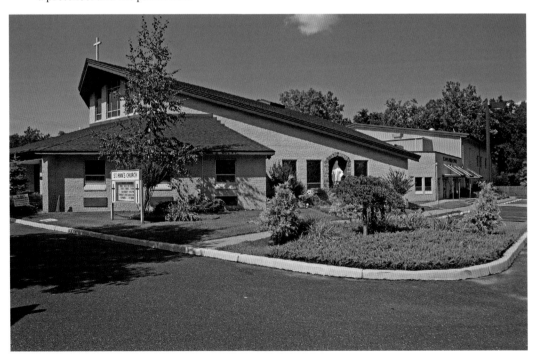

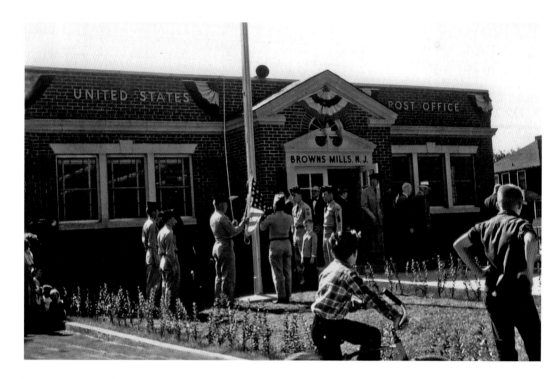

POST OFFICE HOMES: If you were picking up your mail in Browns Mills in 1914, you'd have to go to Hargrove's General Store. There, Postmaster M. Warner Hargrove could also supply you with groceries, bait and snakes. But, as the area grew in sophistication and size, the post office warranted its own building on Trenton Road. That facility was dedicated in September 1958. In the early twenty-first century, a more modern office handles the mail on Brook Street.

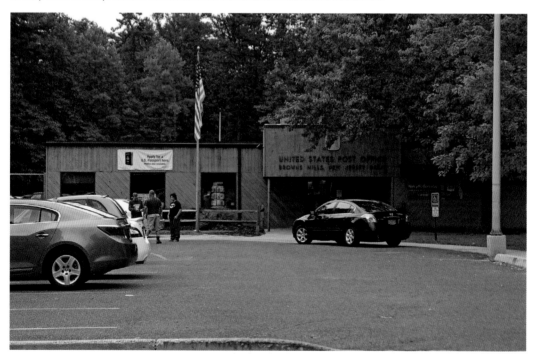

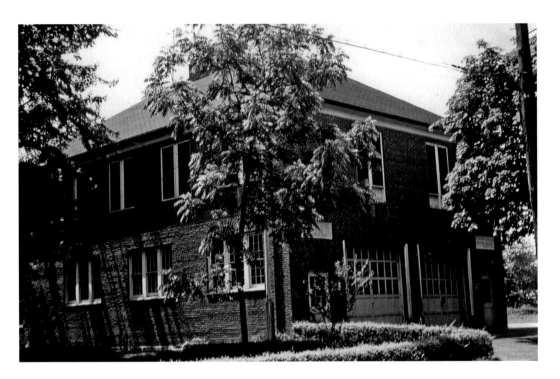

FROM MODEST BEGINNINGS: The Browns Mills Fire Company started in 1922 at a meeting of seventeen charter members over Hargrove's Store where it was agreed that a hand-drawn, two-wheel cart with a fifty-gallon chemical tank would be purchased. In the late 1930s, the new firehouse on Trenton Road replaced the seventy-five dollar Salvation Army Chapel that was the company's first home.

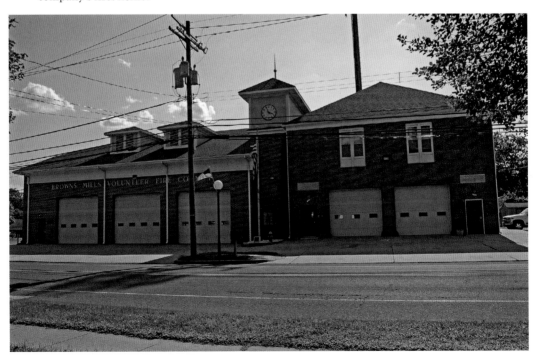

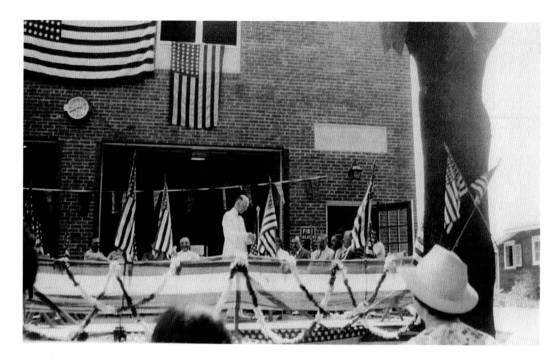

DUAL PURPOSE BUILDING: When the Browns Mills Firehouse on Trenton Road was dedicated with remarks by Dr. Marcus Newcomb on July 4, 1939, it marked the end of the single-bay structure previously used for fire services. But it also heralded a new municipal building for the township. For many years, court was held at the firehouse, and the library was based there. In the mid-1950s, the second floor of the building was converted for use as third-grade classrooms. The new municipal building was built on Pemberton-Browns Mills Road.

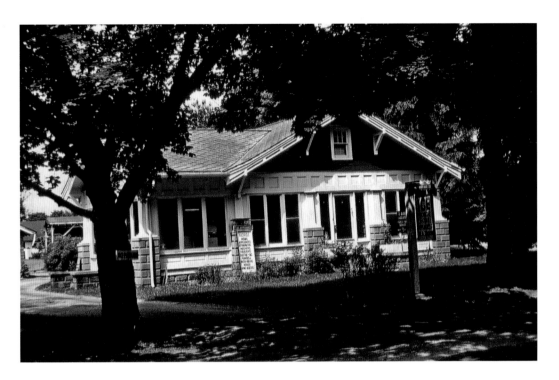

NORGE APPLIANCES AND ICE: If your refrigerator was on the fritz, you could look for a new one at the Norge Appliance Store on Trenton Road, or simply purchase some ice to keep your food cold instead. The original building still exists in that location and houses Sonja's Lily Pond Lodge. An addition several years ago created the Lakeside Café.

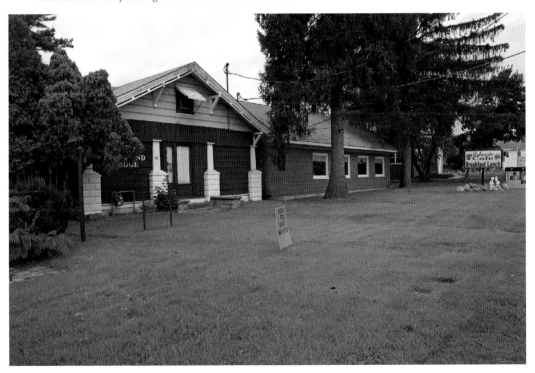

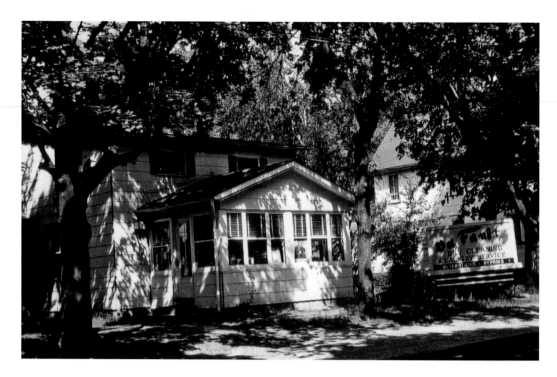

Built for Dry Cleaning: When the DuFault Dry Cleaners building opened in 1949, it was probably not foreseen that the structure would stand to one day house Yoga in the Pines in the year 2014. While it has experienced various uses over the years, the building on Trenton Road is enjoying its new facelift and stress-free existence.

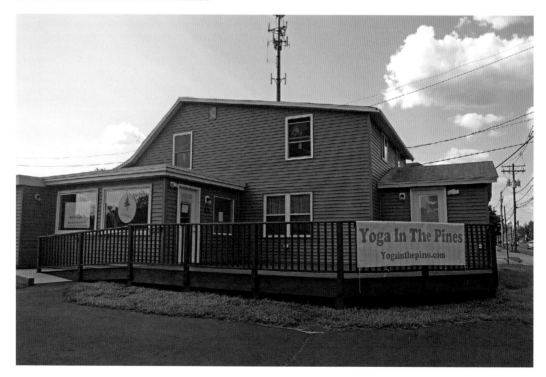

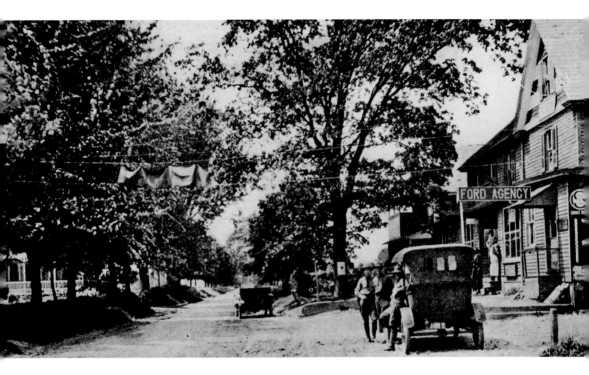

LOVED THE FORD: In 1900, the Ford Agency was located on Juliustown Road, where Cintron Apartments stand in 2014. A new Ford dealership came along by the 1950s, and later moved further down on Lakehurst Road for more space. One could buy a Ford or Chevrolet in Browns Mills and a Chrysler or Plymouth at Yerkes and Sons on Fort Dix Road, but you had to go to travel to Mount Holly to buy a Studebaker.

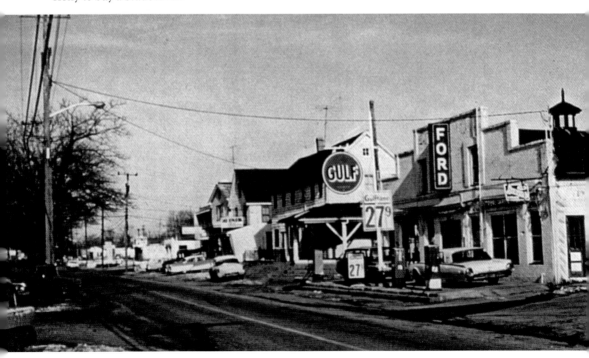

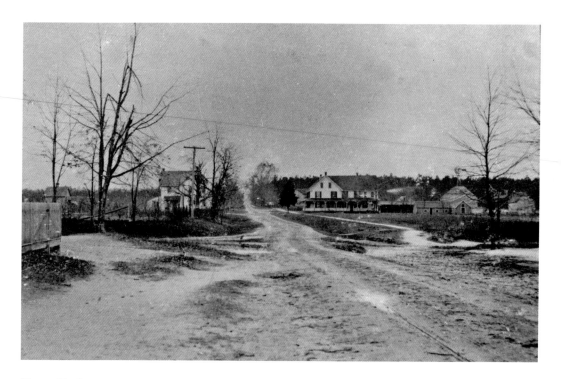

HARD TO IMAGINE: In about 1910, Trenton Road was unpaved and sugar sand was the driving surface. The large building to the left above was Earlin's Cash Market, and across the street was M. Warner Hargrove's General Store and post office. This would have been the view from the corner of Broadway and Trenton. In 2014, that same view is quite different and both of those buildings have been demolished.

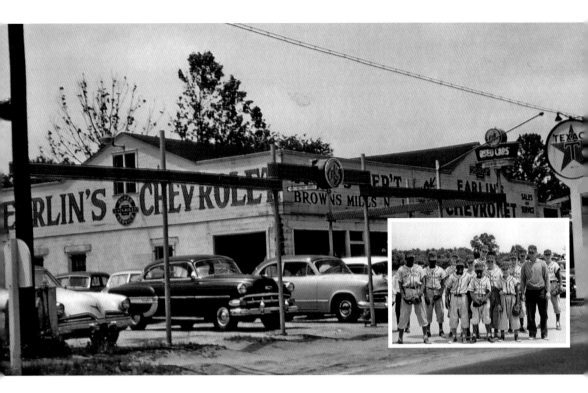

IN THE MARKET FOR A NEW CORVAIR: Earlin's Chevrolet on Trenton Road began operations in 1937 with used cars and expanded to new cars in time for the 1940 line. The Earlin family's involvement in local business and land ownership extended to such civic activities as organizing annual parades and water carnivals and sponsoring Little League Baseball Teams. The DaVita Dialysis Center was recently constructed on the site of the dealership.

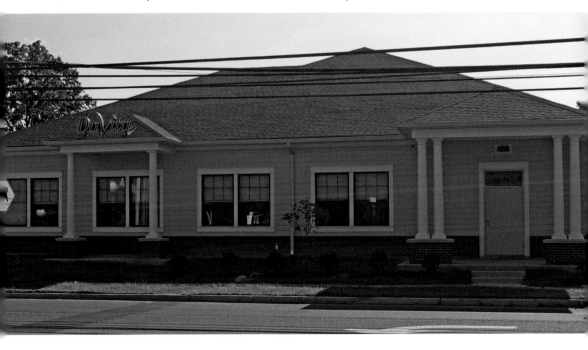

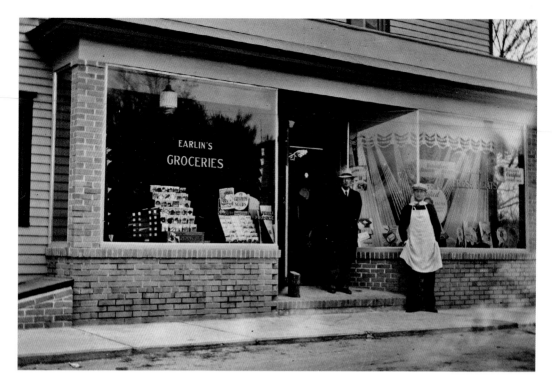

THE OLDEST FOOD STORE: Walter Earlin's Grocery and Cash Market opened in 1895 on Trenton Road. It was a full-service store supplying meats, groceries, staples and produce to the community. Its proximity to Fort Dix kept it in full operation for many years.

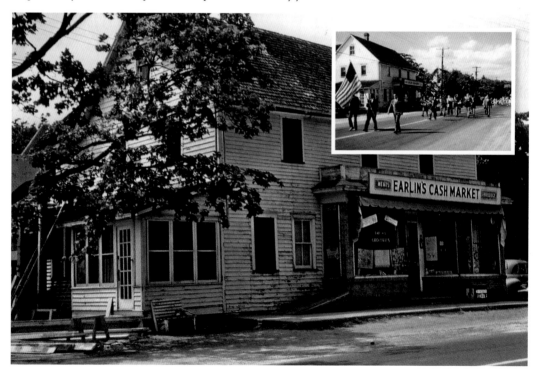

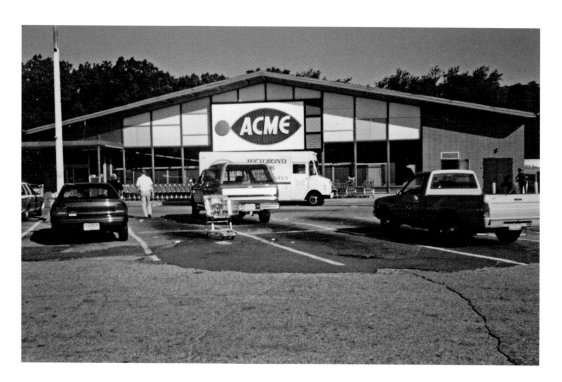

OUT WITH THE OLD: Pemberton Township was at the height of a housing boom when the original Acme Market opened in the Browns Mills Shopping Center on Pemberton-Browns Mills Road in 1962. If a snowstorm were predicted at the time, one would be certain to find the bread and milk aisles barren. The new Acme became the anchor store for the Pine Grove Plaza at Trenton Road and Broadway. It opened on March 3, 1996. The original store remains vacant.

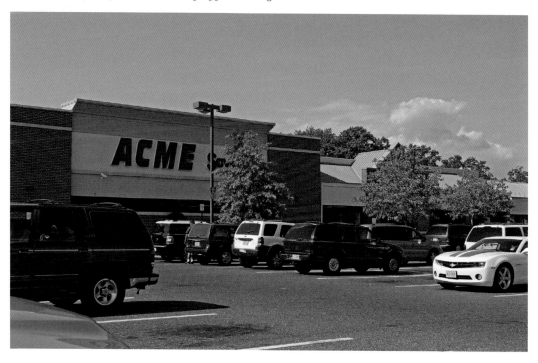

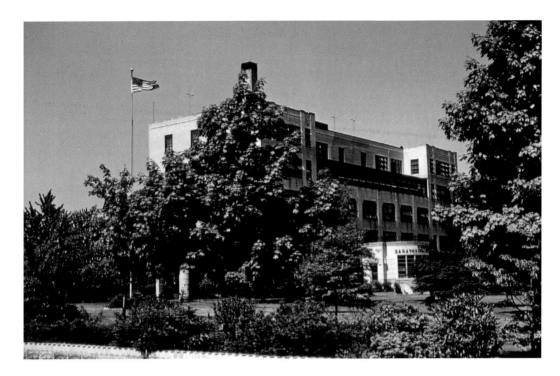

DEBORAH HOSPITAL AND SANATORIUM: Construction on the original hospital began in 1931, with dedication in 1938. The first heart operation was performed at Deborah in 1958. In the 2010s, it is renowned as a world-class heart and lung center, and has expanded to treat numerous related conditions. A new emergency wing has been added in association with Lourdes Medical Center. A worldwide volunteer foundation supports Deborah.

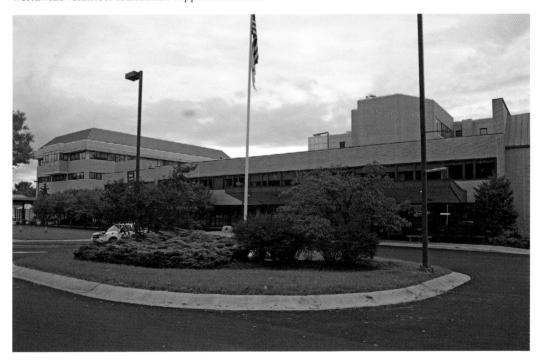

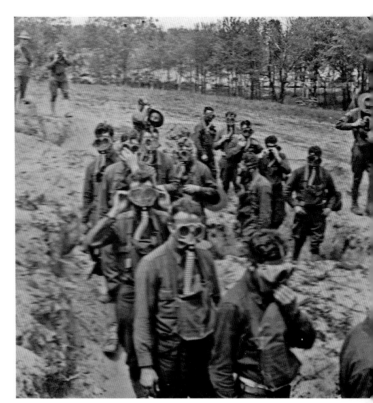

Miles of Training Ground: Joint Base MDL is comprised of 42,000 acres of contiguous land. As it has since 1917, the military facility maintains a variety of ranges for training purposes. In its early days, one of the most important sections was the tear-gas trench, where soldiers were taught proper placement of gas masks. In order to fulfill its mission, Camp Dix required the acquisition of large amounts of land. Pointville was one of the areas accessed by the government. While the cemetery was retained on base, the adjacent Pointville Church was dismantled and sold to another congregation.

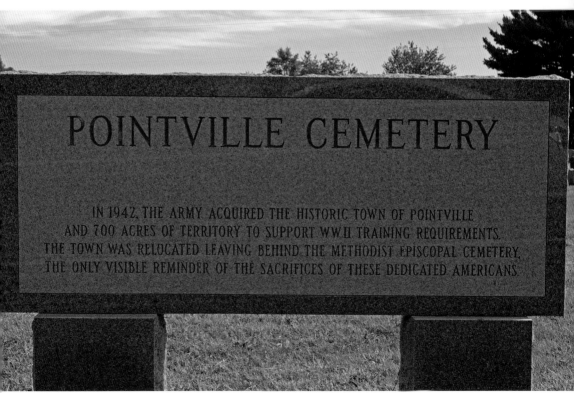

POINTVILLE CEMETERY

IN 1942, THE ARMY ACQUIRED THE HISTORIC TOWN OF POINTVILLE
AND 700 ACRES OF TERRITORY TO SUPPORT W.W.II TRAINING REQUIREMENTS.
THE TOWN WAS RELOCATED LEAVING BEHIND THE METHODIST EPISCOPAL CEMETERY,
THE ONLY VISIBLE REMINDER OF THE SACRIFICES OF THESE DEDICATED AMERICANS.

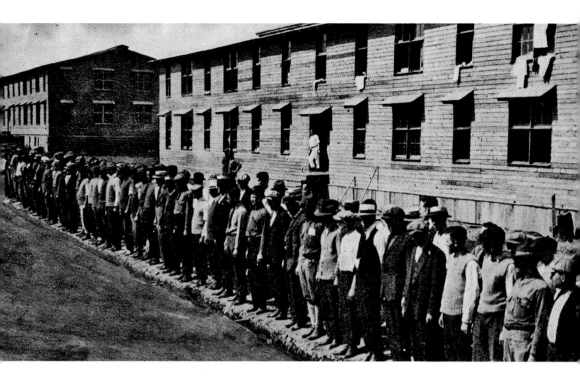

PROCESSING FOR BASIC TRAINING: The first 5,000 draftees arrived at Camp Dix on September 5, 1917. The site was selected by the government five months after the declaration of World War I when 200,000 men were activated and America's camps held room for only 125,000. While the mission of Camp Dix, later named Fort Dix has changed considerably, newcomers still go through central intake at the U.S. Military Entrance Processing Station on Fort Dix Road.

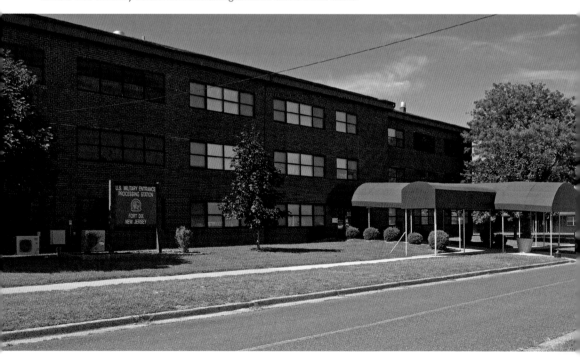

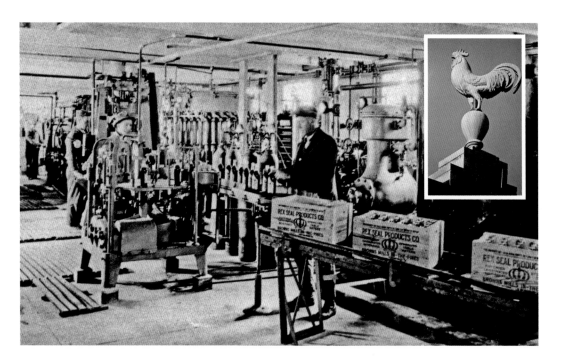

A LEGACY OF BUSINESS STARTS: Commonly known as Peripole in current times, the large brick building with the chicken on top off of Juliustown Road was home to several business start-ups. The Rex Seal Products Company bottled ginger ale in the basement. In later years, a hosiery plant, a bakery and a unique musical instrument manufacturer utilized the facility. It is best known as the Million Egg Farm. One of the more interesting ventures in Browns Mills' early days was the Silver Fox Ranch. Percy Brown reportedly heard a radio ad about the profit on pelts and started that enterprise. He sold the pelts in New York City.

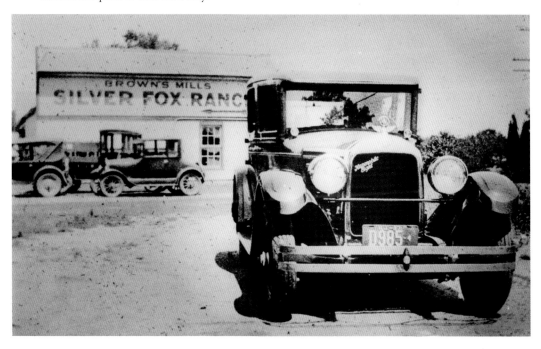

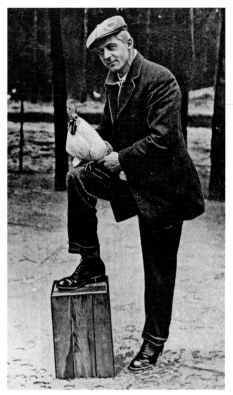

MILLION EGG FARM: By all accounts, Joel M. Foster, who operated the lucrative Rancocas Poultry Farm off of Juliustown Road in Browns Mills, was a success story. Owned by his father's firm, the International Correspondence School of Scranton, PA, the farm was the setting for Foster's textbook on raising chickens at a profit. Unfortunately, it was his "elopement" with secretary Delilah Bradley that won him fame. Foster left a wife and child behind in 1914 when, at age forty-two, he headed for life in Mobile, Alabama with the seventeen year old. After having been fully accepted into Mobile society, the pair's secret was discovered and Foster was tried on violations of the Mann Act governing white slavery. Foster and typical egg-farm workers are shown.

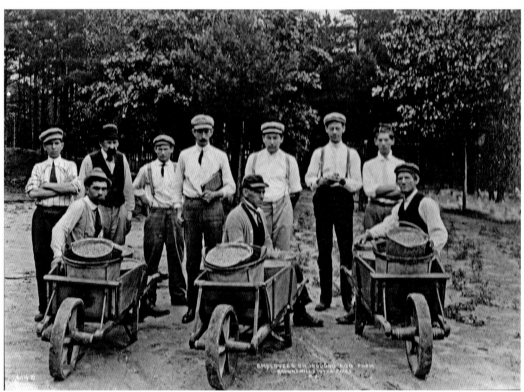

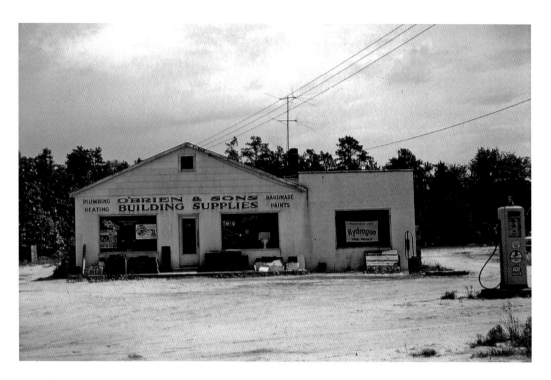

CHANGING INVENTORY: When it began in 1947, O'Brien and Sons Building Supplies offered lumber, hardware, paints, roofing and custom-built homes. In its sixty-seventh year of operation, the family-owned business still carries a full inventory of building supply needs in the same location on Pemberton Browns Mills Road.

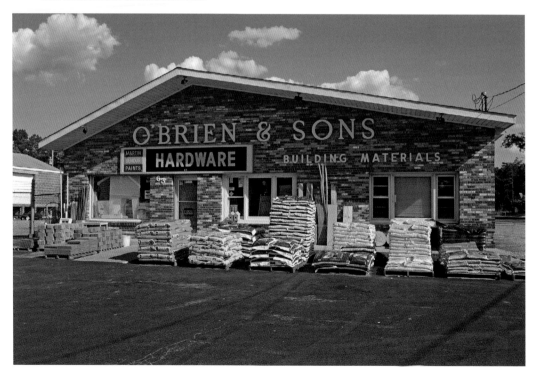

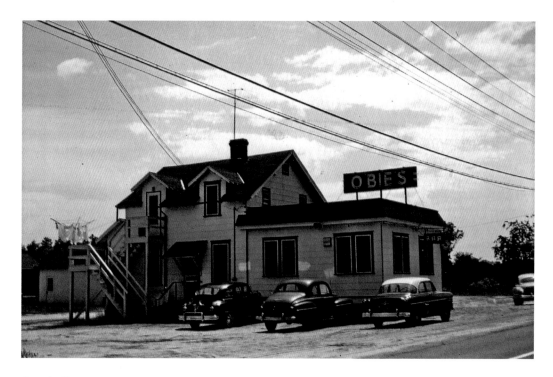

OBIE'S IDLEWYLE: That's how Obie's advertised in its heyday, hoping to draw customers who wanted to idle a while in the company of friends. Many did just that, especially on Saturday nights, when Freddie Staughter's 3-Keys Orchestra was onstage. The Lounge has gone through numerous transformations, and recently reopened as the Browns Mills Liquors and Bar.

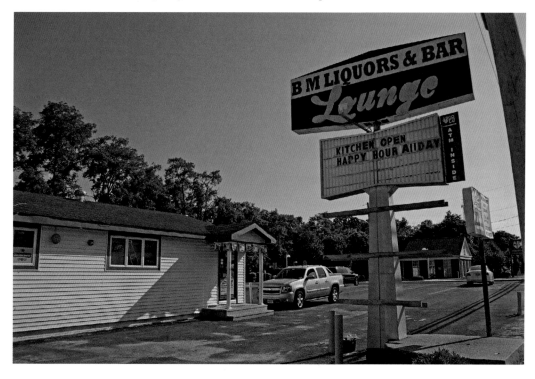

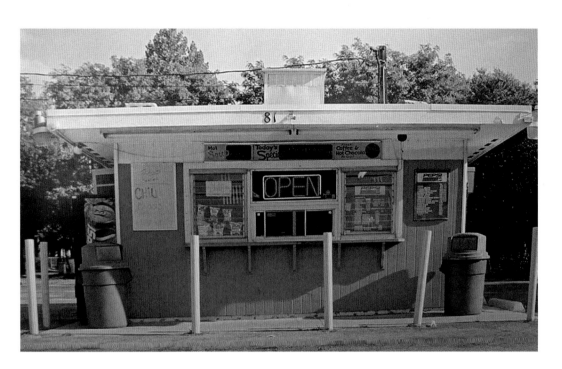

EVERYONE HAD A FAVORITE: Mention Broadway Take-Out in a crowded room of local residents and a menu immediately emerges. While the cheesesteak hoagie was undoubtedly the most popular, those who favored the BLT or eggplant parmesan sandwich will argue their case to the finish. Opened by Bud D'Agostino in 1964 and managed by son Tom Spencer and his wife Sharon, the take-out restaurant closed in the mid-1990s. The ABCO Credit Union was built soon thereafter on the Pemberton-Browns Mills Road site.

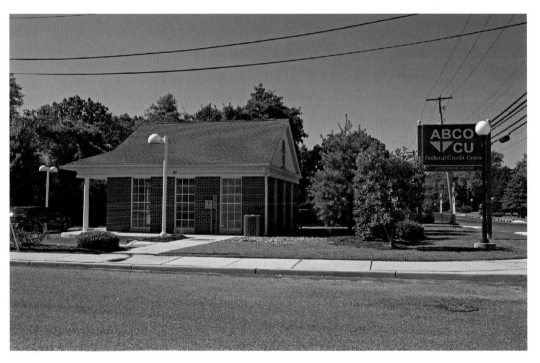

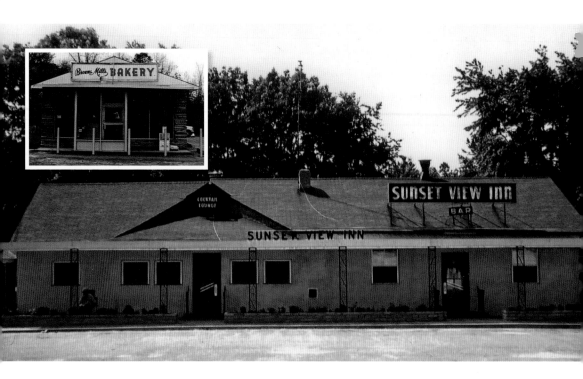

THE GREASE BAND: Saturday nights at the Sunset View Inn on Pemberton Browns Mills Road meant a packed house in the 1970s. The bar drew a young adult crowd of music and dance enthusiasts, particularly when the Grease Band performed. It was set back on the property that was shared by the Browns Mills Bakery for many years. Fresh-baked bread on a Saturday morning was just the thing after a night of dancing at the Sunset. Both buildings were demolished and Beneficial Bank stands in their place in 2014.

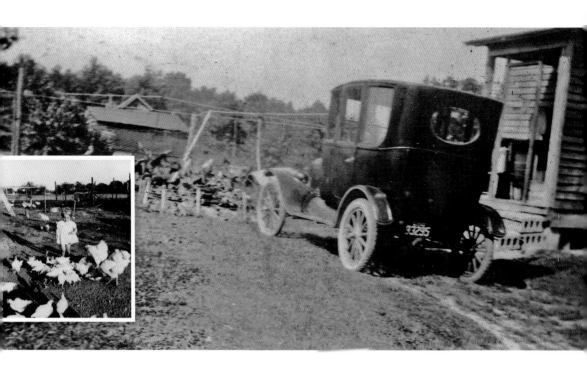

THE PLACE TO GO FOR EGGS: A small group of homes on a cul-de-sac fronting on Pemberton-Browns Mills Road was ahead of its time in the organic egg business. In the rear of the neighborhood, a large chicken farm supplied eggs for many of the area's families. Marge Hulick Senior is shown among the chickens. Along the main road, Josh's Used Furniture and Linoleum helped with furnishing and flooring.

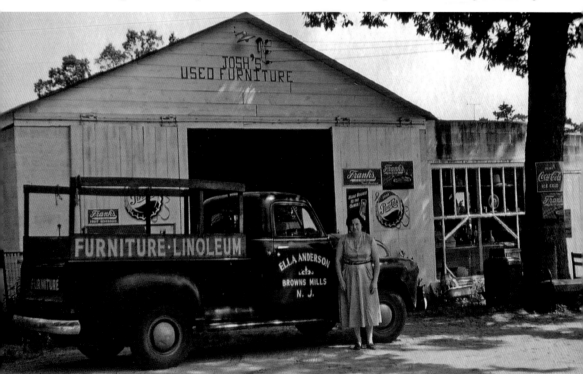

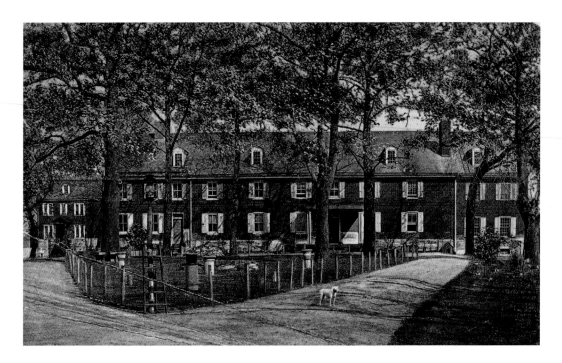

THE BURLINGTON COUNTY ALMSHOUSE: Located on Pemberton Brown's Mill Road in 1801—when the county purchased the Josiah Gaskill farm—the almshouse was overseen by the freeholder board. Prior to its erection, each town within the county was responsible for providing for its indigent citizens. The building was destroyed by fire in March 1937 and residents were transferred to the Birmingham Inn. Over the years, the site was home to a number of county facilities, including the Hospital for the Insane or Evergreen Park and Buttonwood Hospital. In 2014, the Aspen Hills Health Facility occupies the land.

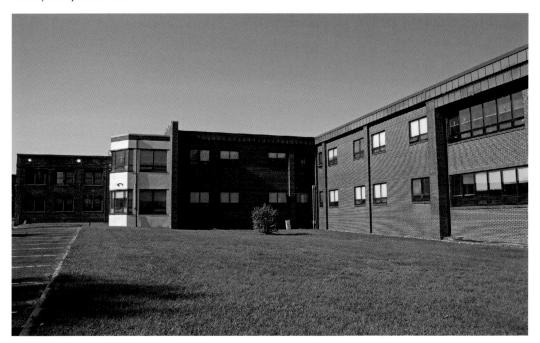

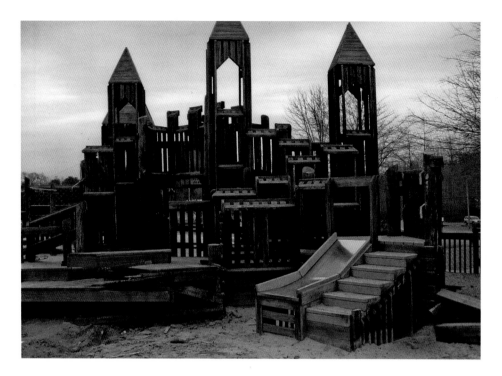

BUILT WITH GREAT PRIDE: The area's largest playground complex was built, demolished and built again by dedicated volunteers. Imagination Kingdom on Pemberton-Browns Mills Road was originally designed in concert with local children and erected by an army of volunteers over five days in 1993. When the treated timber used in its construction was deemed unsuitable for longevity, Imagination II plans began. Resident Bryan Jenkins led the design team for the largest community-built playground in New Jersey, made mostly of recycled materials. It was erected by more than 200 volunteers over two weekends in 2009. Celebrating its success are Colleen and Mollie Newman, Marty, Nicholas and Sarah Ward, Lee Ann Emery, Alexis Petras and friends.

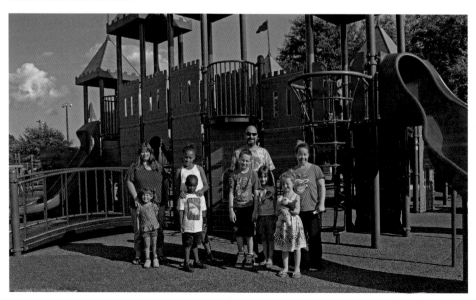

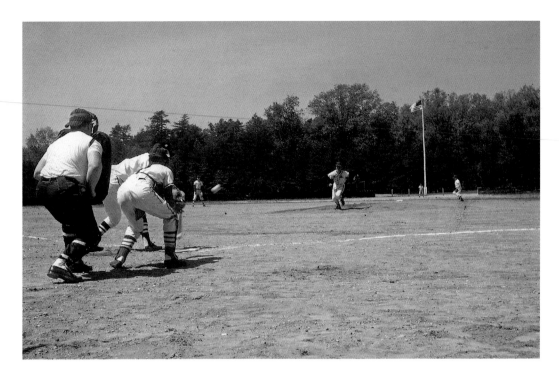

FITTING FIELDS: Over the years, Pemberton Township has always made space for recreation, and baseball was no exception. This sandlot field once stood where the bus garage sits on Juliustown Road in 2014. In modern times, area youth practice and play the sport at a complex containing several fields and a clubhouse and storage facility on Pemberton-Browns Mills Road.

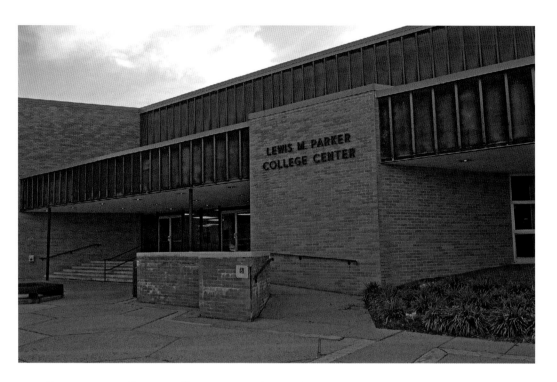

BURLINGTON COUNTY COLLEGE: While founded in 1966, the college on Pemberton-Browns Mills Road did not open until 1971, with the completion of the Lewis Parker Center and the physical education building. Since that time, a new academic center has been added, as well as an extensive library. Campuses have opened in Mount Laurel and Mount Holly in recent years.

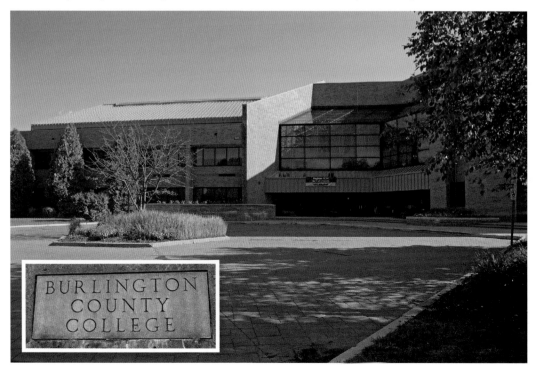

WILLIAM SEEDS: As his land and possessions were auctioned for final sale in 1928, William Seeds was on his deathbed in the first-floor bedroom of this home. Auctioneer Clifford Powell hawked the wares of the eighty-five-year-old Civil War veteran from the doorway of the home. At one point, he held up two muzzle-loading rifles and caused the women to shriek, as a bidder shouted, "Be careful, they're loaded!" In the end, the 100-acre Seeds family farm on Pemberton-Browns Mills Road sold for $4,500, and William Seeds died the next day. Just to the right and behind the Ella Nesbit Center and football fields on Pemberton-Browns Mills Road was a driveway leading back to where the Seeds farm once stood. In 2014, the driveway is overgrown and the land remains wooded.

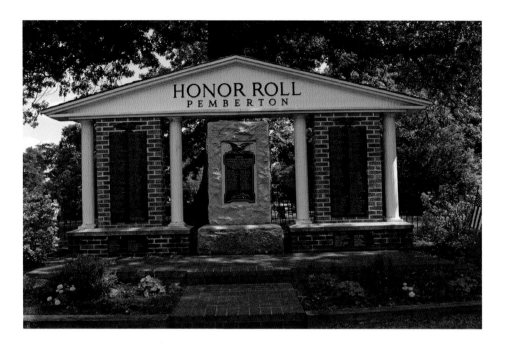

LOCAL LEGACY: The original Pemberton Borough Honor Roll on Hanover Street was dedicated on Memorial Day 1945. Years later it still stood, but the names of many who had lost their lives in conflict after World War II were missing. Resident Florence Thorne spearheaded a committee to raise the necessary funds for the rebuilding and addition of missing names. The new memorial was dedicated in May 1992. Meanwhile, the old one-room lockup on St. John Street in the borough has also benefitted from volunteer community support. Residents put a new roof on the building in 1989. Legend has it that the only prisoner ever held in the 1887 lock-up unscrewed the nuts on the cell door and jumped a train out of town in the first year of its existence.

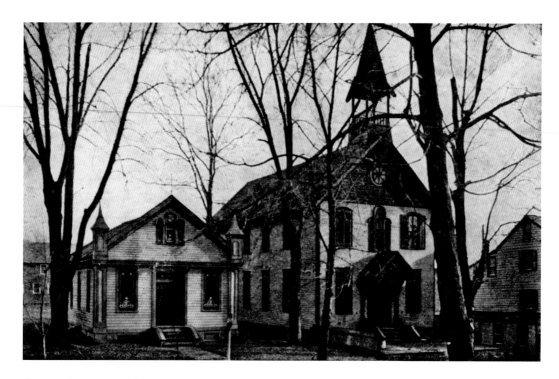

GRACE EPISCOPAL CHURCH: Initially, congregation members met in the lower floor of the Odd Fellows Hall, which had been fitted as a chapel, until 1861. They purchased that church in 1861 from the Baptist congregation, which had erected it in 1843 for evening meetings in town and Sunday-school use. The new church was built in 1938 on Elizabeth Street.

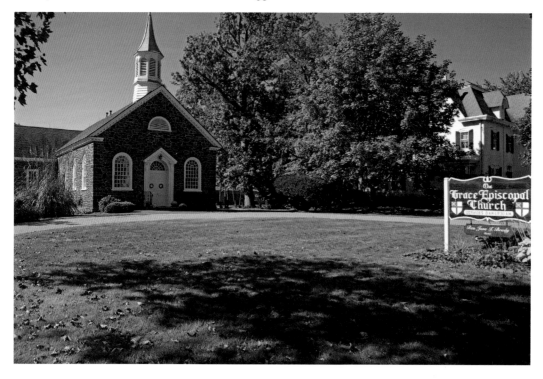

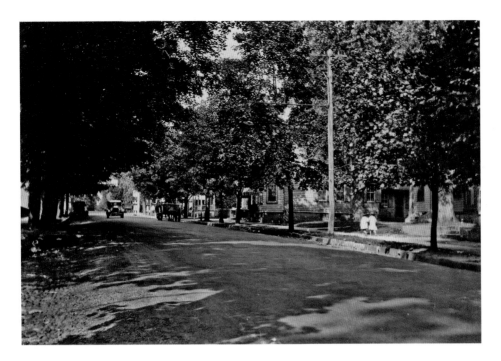

ELIZABETH STREET: While the borough was well established as a "company town" by 1787 with the grist mill, a number of homes, a forge, fulling mill, coal house and a blacksmith shop, Elizabeth Street did not yet exist. Neither did Hough, Jane, Egbert Streets or Budd Avenue, for that matter. They were still heavily wooded areas. In 1882, however, an iron-works was in full operation, the borough had just been incorporated and "every business scheme" was "floating on the high tide of prosperity," according to historians. It was then that the stately homes lining Elizabeth Street began to be built.

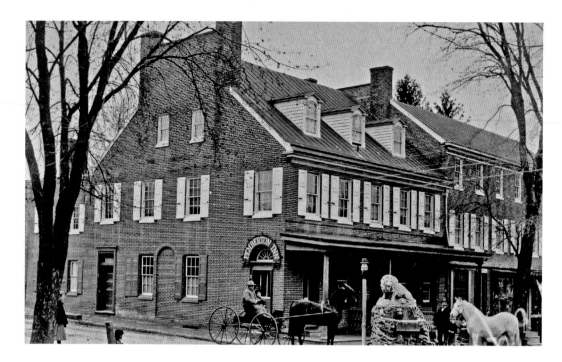

THE UPPER TAVERN: Prior to 1800, Daniel Wills owned the old hotel that became known as the Upper Tavern. Over the years, it had a number of owners, managed either in combination with or separate from the lower tavern not far away on Hanover Street. Leo the Lion, a famous hitching post at the Upper Tavern, was moved to the park on the corner of Hanover and Mary Streets when the park was built. The old tavern building holds apartments in the 2010s.

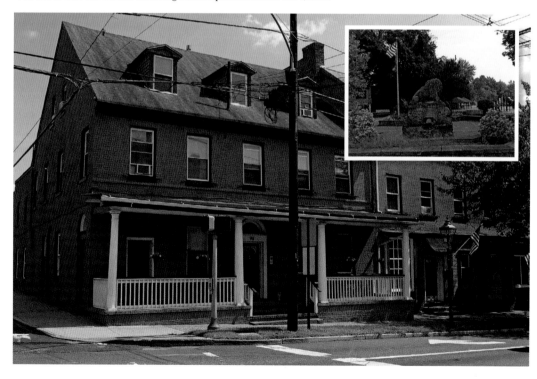

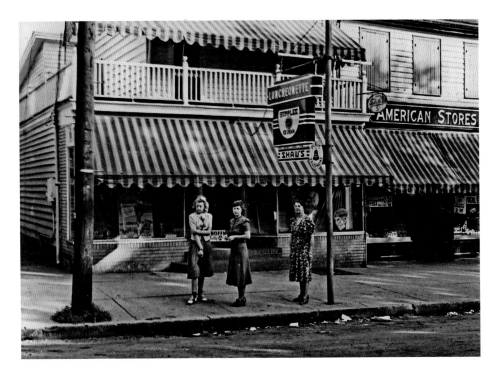

GROCERY STORES: Long-time borough resident Bob Haines once recalled that there were four grocery stores on Hanover Street at one time—one in the furniture store, one right below the funeral parlor, an A&P, and an American. He worked in all of them. "On Saturdays," he said, "we'd put all of the fruit in front of the store. You'd get so much food for twenty-five dollars that you couldn't even carry it." In 2014, the South Jersey Coin and Gold Exchange stands where the American was located.

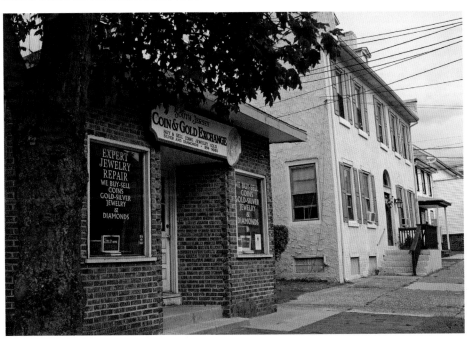

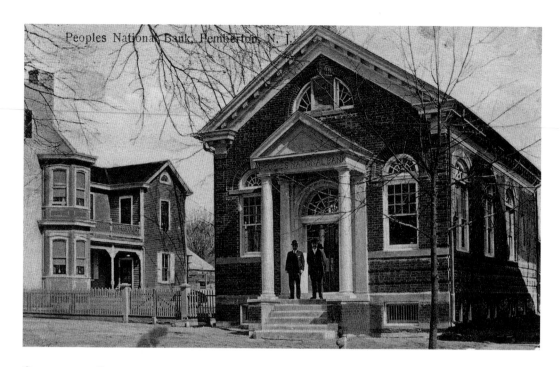

Peoples National Bank, Pemberton, N. J.

COMMUNITY SERVICE: Built as the People's National Bank in 1908, the Hanover Street building has served the community in several ways. Commercial space in 2014, it was utilized as Borough Hall for many years. The large bank vault on the first floor of the building was utilized to store municipal records during those years, and what had once been the teller's floor served as municipal meeting space. The new municipal building on Egbert Street opened in 1992. The 1801 hand-pumped fire engine cart was lowered into the borough's Historical Room by crane before the roof was built on the new structure.

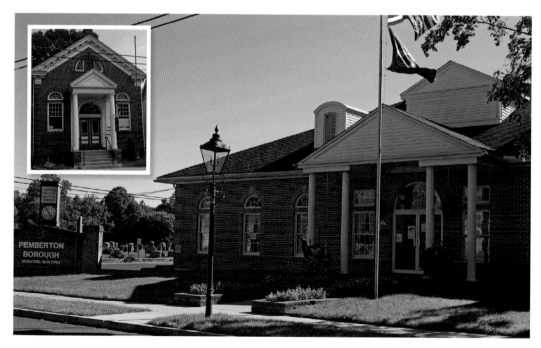

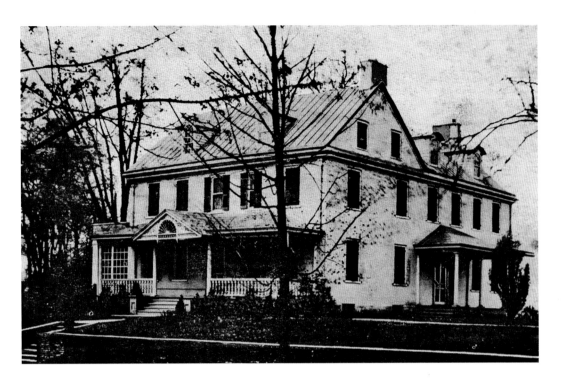

HISTORIC BUDD RESIDENCE: The Theodore Budd residence on Hanover Street in Pemberton was once occupied by Col. Thomas Reynolds, who served in the American Army during the Revolution. It has been reported that he hid from the British in a barn behind the home at one point to avoid capture by the Redcoats. George Washington was rumored to have stayed at the house for a short time.

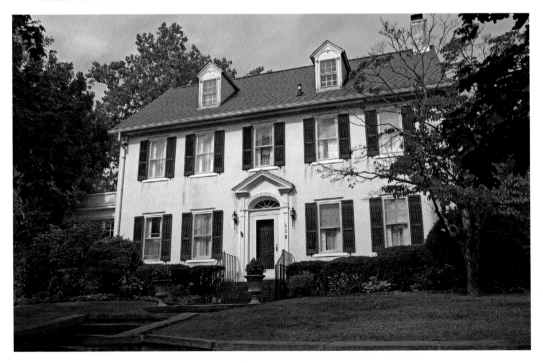

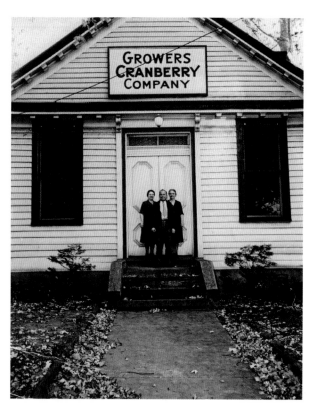

CRANBERRY BLOSSOM:
The building known as Cranberry
Hall started out as a church built in
1843 for $700 by a Baptist minister. In
the years that followed, it was home
to the Growers Cranberry Company.
Walter Fort, shown here with his
wife and mother, started out with
the company in 1947 as a growers
relations man. He worked with
farmers, distributors and agricultural
experts studying cranberry
production and trends. In 1984,
Norma and George Ward purchased
the Hanover Street building and
revitalized it to house the Cranberry
Blossom Floral Company.

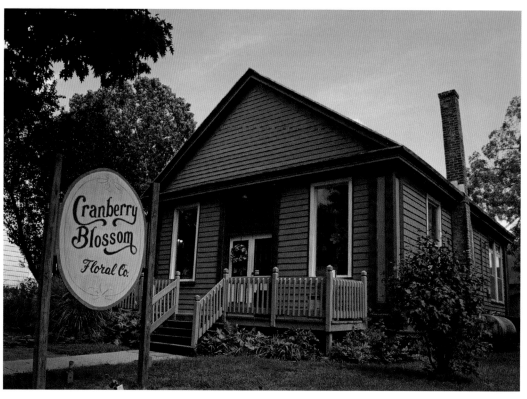

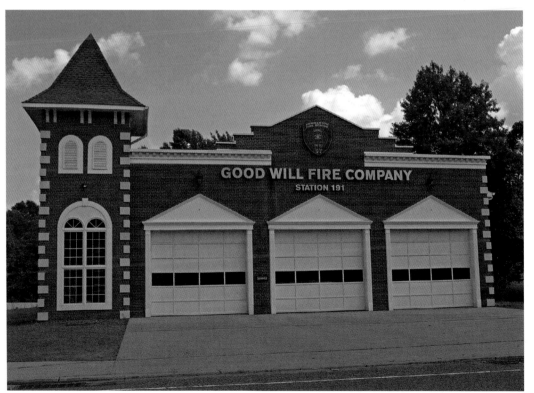

IN ITS INFANCY: The village originally known as New Mills had a bucket brigade known as "The Ever Readies" that doused local fires. In 1818, the protection was formalized by the creation of the New Mills Fire Company, a name that would change several times before 1894. In that year, fire struck in earnest and threatened to level the town, and the Good Will Fire Company was incorporated. Its first home on Hanover Street has been converted for public use and the new firehouse further down the street near the creek offers more space and modern amenities.

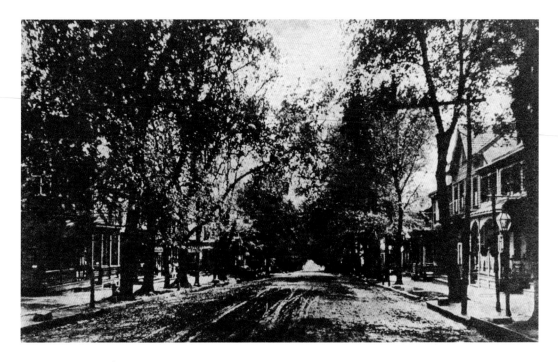

ROUTE TO THE SHORE: Before the advent of highways, the only way to drive to the shore was through Pemberton Borough. Bob Haines, who lived here for more than eighty years, recalled that in those days, Mayor Harry Hartman used to carry a whistle and used it to stop traffic on Sundays. By mid-day, said Haines, residents would be sleepy due to the inhalation of auto exhaust. The opening of the Borough Bypass in 1991 helped greatly, and in the 2010s, Hanover Street is actually able to close each fall for the annual Fall Fest and Duck Race on the creek.

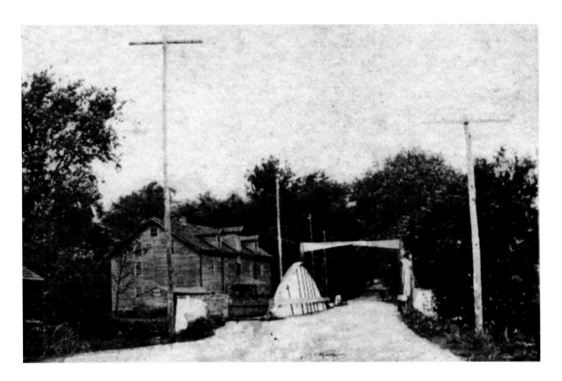

THE BOROUGH GRIST MILL: When David Budd conferred land to partners Patrick Reynolds and Robert and Daniel Smith to build the grist and saw mill in 1752, even the name of the town was changed. It went from Hampton-Hanover to "New Mills" as indication of the industry and success that was to follow. The original mill was destroyed by fire in 1847 and rebuilt in 1850. After falling to disrepair, the building was rebuilt in 1978 and opened as a family restaurant for a short time.

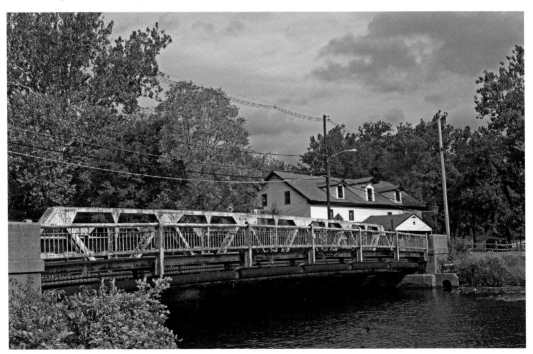

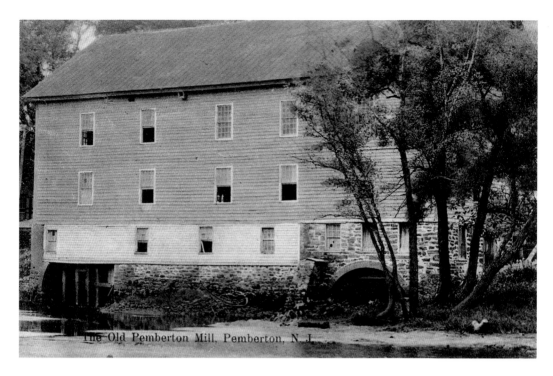

The Old Pemberton Mill, Pemberton, N. J.

GATEWAY TO THE BOROUGH: Pemberton Borough's first grist mill was located on Budd's Run in 1740 at the north side of town, just east of where Hanover Street crosses the stream. Its relocation nearer the creek came in 1752. Its revitalization as the Grist Mill Antiques Center fulfilled a dream of the town fathers by bringing in a new business with old charm.

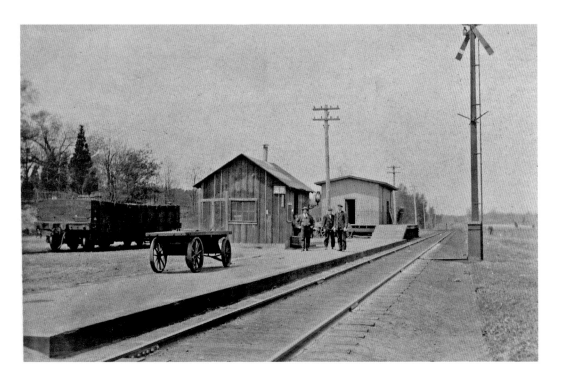

THE FIRST SOUTH PEMBERTON STATION: The place for residents to catch a southbound train in the early days of the railroad's presence was on Hanover Street in Pemberton near the 2014 location of Creekside Glass. When the new South Pemberton Station was built, it was located at the intersection of what has become Route 38 and Hanover Boulevard.

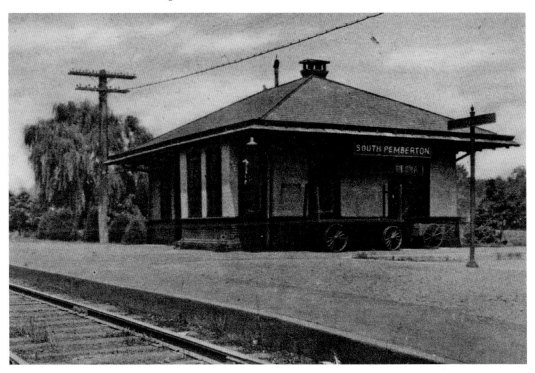

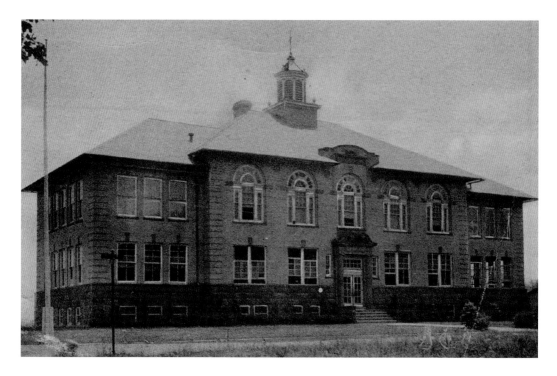

HOME OF THE CORN HUSKERS: The Pemberton High School located on Egbert Street in the borough was built in 1912 and graduated its last class in 1959 when the new school was erected on Fort Dix Road. That facility was converted to a middle school complex with the addition of a new high school on Arney's Mount Road. At various points in its history, the Borough School housed the local library, and an agricultural building existed next door. Study hall was held across the street at the Grange Hall.

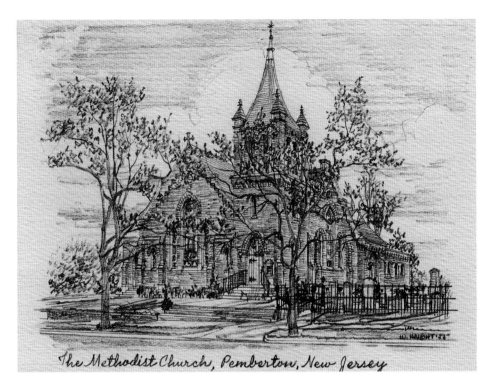

The Methodist Church, Pemberton, New Jersey

METHODIST CHURCH: In 1769, residents of "New Mills" held Methodist services in their homes. The first meeting house was built in 1775 on Hanover Street with a parsonage next door. On May 16, 1894, the church parsonage and horse sheds were destroyed by one of the worst fires ever experienced in Pemberton. Seven homes, two stores and several barns were also involved in the fire. The second-oldest Methodist Church in New Jersey, the congregation just celebrated its 245th year.

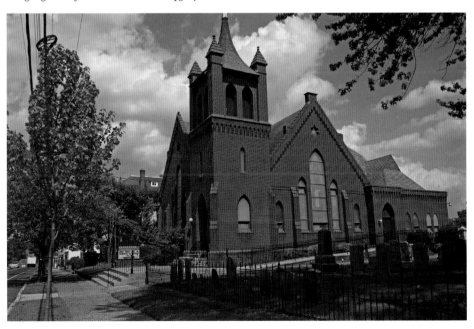

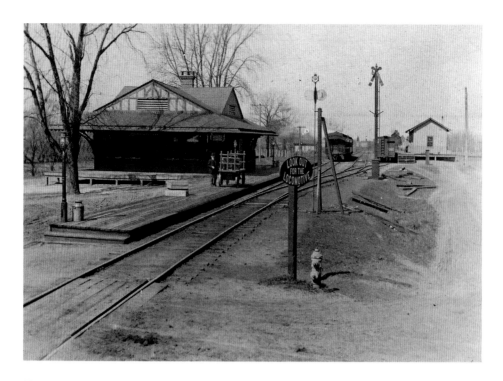

NORTH PEMBERTON STATION: Built in 1892, the station located on Fort Dix Road is recognized on the National Register of Historic Places. While rail operations ceased with the end of the Pemberton and Camden trains in 1969, the station holds promise as a museum and the site of the local extension of Rails-To-Trails. Owned by Pemberton Township, the station is closed. The rail trail was originally developed and maintained by the Pemberton Rotary Club.

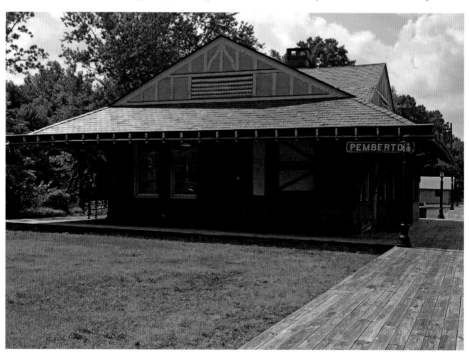

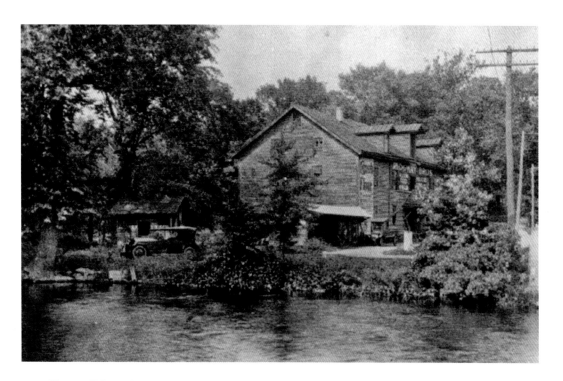

THERE WAS A TIME... When you could park your motor car down by the mill, untie the canoe and drop it into the Rancocas for a leisurely afternoon on the creek. It's actually any weekend day, thanks to Clark's Canoe Rental. And you no longer have to drag the canoe along. An original blacksmith shop dating back to 1752, Bud and Irene Clark opened the canoe rental operation in 1990.

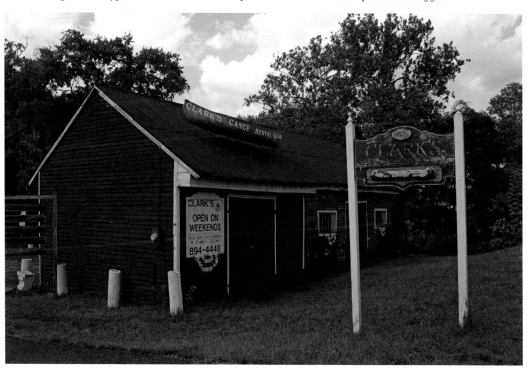

Acknowledgements

With grateful thanks to Duane Jenkins, whose love for local history is unsurpassed, and to fellow collectors Brett Nasti, Joe Anderson and Ann and John "Mike" Hulick, who willingly shared their prized collections for scanning. Thanks also to contributors and consultants: Dottsie Anderson Brem, Charles and Dona Jenkins, John and Janet Nallinger, Roger and Nancy Pittman, Charles McKinstry, Albert Klitz, Kevin Dowd, Skip Clayton, Tom Walker and dear Mr. Robert Farrell. Appreciation to Pemberton Borough Mayor, Council and Administration for access to the town's History Room. Endless gratitude to the Burlington County Library for making *The Times Advertiser* and *Community News* available on microfilm.

Throughout this book are photos taken by Ramona Earlin Montovani and shared by her son Brett. One summer as a young woman, Ramona set about town to chronicle local businesses. Perhaps the act was meaningful for her because of the long business history of the Earlin family in the area. Perhaps she had a new camera and was bored. By the time the photos were discovered, she was not able to tell the story. But we're ever grateful for this simple act by a young woman in a yellow dress on a hot summer day. It mattered.

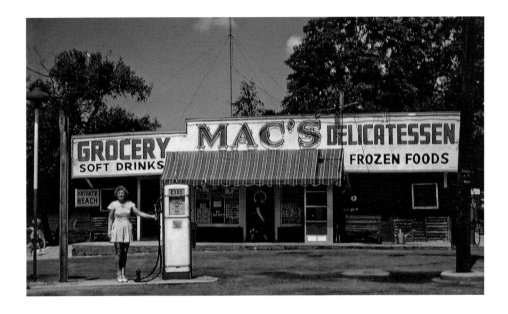

Ramona Earlin Montovani
1937–2011